drawing now

TRACEY

drawing now
between the lines of contemporary art

I.B. TAURIS
LONDON · NEW YORK

Published in 2007 by I.B.Tauris & Co Ltd
6 Salem Road, London W2 4BU
175 Fifth Avenue, New York NY 10010
www.ibtauris.com

In the United States of America and Canada distributed by Palgrave Macmillan
a division of St. Martin's Press, 175 Fifth Avenue, New York NY 10010

ISBN: 978 1 84511 533 3

A full CIP record for this book is available from the British Library
A full CIP record is available from the Library of Congress

Library of Congress Catalog Card Number: available

Typeset by JCS Publishing Services, www.jcs-publishing.co.uk
Printed and bound in Great Britain by CPI Antony Rowe, Chippenham

contents

preface

TRACEY is an online peer-reviewed journal, hosted by Loughborough University (School of Art and Design), which publishes and disseminates material concerned with contemporary drawing research. The journal aims to stimulate open-minded and contemporary interest in drawing activity — physically, cognitively and creatively. It represents many perspectives on drawing, including fine art, architectural design, graphics, product design and visualisation. It endeavours to question preconceptions and to encourage the potential for drawing.

The editors of this book — Simon Downs, Russell Marshall, Phil Sawdon, Andrew Selby and Jane Tormey — are the editors of TRACEY. The idea for TRACEY originated with Jane Tormey in 1999, and the journal was first published in 2000. It was born out of the realisation that there was considerable international drawing activity and some debate, but limited opportunity to publish beyond monograph, catalogue and review. As the journal has developed editors

have come and gone, including Lorenzo Madge, Martyn Blundell, Judith Mottram and George Whale, with Jane Tormey and Phil Sawdon as constants from those earlier years.

The name TRACEY derives from a combination of the words trace, traceur and trait (Derrida's use of trait contains a range of meanings — feature, line, stroke, mark). The French concept of traceur does not only mean 'to draw' and definitely does not mean 'to trace'; rather, it implies a direct creation and transcription of the mental plane to the material — a mark being made, a creative vector. This process is so inherently dynamic that in recent years it has came to mean a practitioner of Parkour — one who leaps obstacles and jumps chasms with defiant energy. This describes TRACEY, too: restless and inquisitive, with a broad view of what drawing is.

Drawing Now includes the work of a number of artists who manifest and materialise their ideas through the practice

of drawing. TRACEY's initial brief was to select images that challenge what drawing can be — that show how drawing might extend familiar possibilities, such as the figure or landscape, and what drawing might encompass in abstract and conceptual ways, by demonstrating the contemporary use of materials associated with drawing, such as pencil, charcoal, pastel, pen and ink on paper.

This book is not an objective survey of drawing, and neither does it aim to advocate any particular position of what drawing should or should not be. Instead, it asks questions that might suggest further direction and investigation. Drawing Now reflects an interest that emerges in and through the selection process. It quickly became clear that our main concern was the subjective nature of drawing, with its characteristics of awkwardness, resistance to 'conventional' subject matter and to academic style — a leaning toward a conscious naivety, perhaps, and a denial of the signs of 'good drawing'.

introduction

The *thought of drawing*, a certain pensive pose, a *memory of the trait* that speculates, as in a dream, about its own possibility. Its potency always develops on the brink of blindness.[1]

Drawing Now: Between the Lines of Contemporary Art develops a consideration of drawing's peculiar dependence on a direct and physical process — the relationship between the hand, the drawing material and the paper. The book is founded on the premise that drawing thinks/talks in a particular way. With that in mind, this introduction discusses a number of issues provoked by the drawings, rather than reviewing their content or quality directly; the drawings are referred to, but are largely allowed to speak for themselves. *Drawing Now* is an attempt to identify activity that touches the limits of drawing, while conforming to a definition that confines it to paper and certain traditional materials.

The images in *Drawing Now* challenge what drawing can be: how familiar possibilities, such as the figure or landscape, can be extended, and what it can encompass abstractly and conceptually, by demonstrating the contemporary use of materials associated with drawing, such as pencil, charcoal, pastel, pen and ink on paper.[2] It quickly became clear that our main concern was the subjective nature of drawing (over objective, observed study), with its characteristics of awkwardness and a stubborn resistance to 'conventional' subject matter and academic style — a leaning toward a conscious naivety, perhaps, and a denial of the signs of 'good drawing'. These characteristics of

contradiction and opposition developed as a loose framework for selecting the images, and for subsequent reflection. The result is not an objective survey of drawing, but rather a reflection of an interest that emerged in and through the selection process. *Drawing Now* does not advocate any particular position on what drawing should or should not be, but rather asks questions that might suggest further direction and investigation. What do we mean by conceptual? Are conceptual drawings theoretical, abstract, intangible or ambiguous? What themes emerge from the selection?

Drawing Now presents drawing within the notion of contemporary fine art practice as offering potentially challenging subject matter, rather than easily digestible forms such as the figure or landscape. That is not to say that figures and landscapes do not feature; however, the book provides a sample of drawing activity that is positive, celebratory and beyond what might be termed 'figurative'. The selection aims to present drawing by traditional means with a conceptual edge, with an emphasis on how the process of making the drawing contributes to its content, a concept which we describe as 'performative'. It provides an opportunity to scrutinise what might be currently valued in drawing: its simplicity and obsessive nature in terms of the application of traditional materials; its capacity to reflect postmodern preoccupations of appropriation, fragmentation and indeterminacy; its capacity to express in contrasting ways through gesture and allegory; and its potential to challenge what might be considered aesthetic.

Many existing studies are significant in establishing a context for the ongoing debate about the importance of drawing. The Bernice Rose exhibition and catalogue, *Allegories of Modernism, Contemporary Drawing* (MOMA 1992), marked an important point in the re-recognition of drawing toward the end of the twentieth century. Rose highlighted a resurgence of gestural drawing, large-scale work, and approaches to collage and montage. Eleven years later, *Drawing Now, Eight Propositions* (MOMA 2003) proposed that since the 1990s drawing has demonstrated a 'return to subject matter, narrative and the figurative'. Such a contrasting emphasis within this short time span invites a further look at what is happening in contemporary drawing. The return of 'subject matter and narrative' suggests that these have either not been evident in recent years, or that, by its nature, narrative must be figurative and recognisably representational or 'realistic'. We would argue that, in the popular imagination at least, associations with drawing have persistently remained with figurative representations — a view that refuses to absorb either of these two exhibitions' assertions. *The Stage of Drawing* (2003),[3] which featured drawings from the eighteenth century to the 1980s, offered a different debate, which focused on perspectives that align drawing with thinking and ideas, rather than with representing the appearance of objects. *Drawing Now* picks up ideas that this exhibition introduced, and relates a development of this discussion to drawings since 2000. The result is a focus on the kind of drawing that derives from

reflection rather than from observation, and which accesses a different sort of knowledge to that gathered from perception. Instead of the translation of visual appearance, *Drawing Now* emphasises two aspects as central characteristics of drawing: the performative and the speculative.

The resurgence of interest in drawing may have something to do with what Arthur Danto has identified as the point that marks the 'before and after of art'.[4] He suggests that at some point in the twentieth century (precisely, 1965), the role of art changed so enormously with regard to its cultural significance that it appears to have reached a hiatus or crisis point, according to your point of view. If the story of art is a 'great and compelling narrative', Danto suggests that we have reached the point where we recognise its end. The story of art emerged in the Renaissance, with artists as 'great' masters, moved through the progressive and heroic period of modernism, and has now reached the ultra self-consciousness of postmodernism, where the artist's practice has become part of a discourse that critiques rather than represents. A more extreme view, expressed by Jean Baudrillard, states that art can only now reiterate what has gone before.[5] However, drawing, its process, its role and its meaning, is unique in its shared and consistent use throughout history. To some extent it remains outside, or at least beside, this narrative. If it is seen as separate from art's history, drawing can therefore be viewed in two ways: either as another means to participate in an art in crisis, or as a means to escape the boundaries of current aesthetic trends. Being bracketed off from the mainstream has facilitated the current popularity that reiterates its particular properties.

Drawing is the primal means of symbolic communication. It predates and embraces writing, and functions as a tool of conceptualisation parallel with language. It is the artistic medium that is least interrupted by technical considerations, and therefore the chosen means for the initial formulation of visual ideas and the transfer of the appropriation of visual culture.[6] Much writing about drawing has a eulogising tone. Drawing is described as a primitive technology and, as such, a readily accessible means of visualisation (what Deanna Petherbridge has referred to as 'the primal nature of drawing'), which can make us grasp reality in an immediate way. It is said to demonstrate the relationship between reason and intuition, between sensory perception, interpretation and the process of understanding. Its position near to the conception of ideas, and before the refinement of methods, means it can retain a freshness, an idiosyncrasy and a transcendence of historical postures. Drawing lends itself to the expression of its subject matter in a direct way, and allows a model of representation that maps the fragmented simultaneity of thought, accessing memory, visual fragment and intangible imagination. Unencumbered by more sophisticated or 'finished' processes, such as painting or more 'advanced' technological methods, drawing's simplicity seems more able to demonstrate the complexity of conceptual possibilities. It can be remarkably and peculiarly potent.

An ongoing debate in the drawing community is that of the nature of drawing's 'language' — its systems and methods.[7] Drawing is driven by conventions, which start with the translation of mass and light into a line (that does not exist) following the edge of the mass. Norman Bryson describes the academy as moving through a series of received schemata that mediates by means of a 'set of templates or hieroglyphs, for "hill" "tree" "foliage"

"atmosphere"... agreed ... collectively as a visual language'[8] and that in consequence 'all academies look very much the same'. Drawing does not have to conform to the conventions of any particular time, so it is liberated from the 'protocols of line, whose mastery constituted the backbone of the Western artists' visual education.'[9] A resistance to this 'language' that gestures and expresses appears to be a common theme in contemporary drawing; in some instances, artists bypass the properties peculiar to drawing, and use it only because it conveniently refuses the pretensions of other more complete and complex forms. However, whether contemporary practice has relinquished this 'tyranny' of 'language' and the 'totality' of image to any degree is doubtful. Petherbridge refers to the use of a 'dumb line', by which she means 'a line which is not eloquent in the language of drawing'[10] and which does not demonstrate a sophisticated awareness of the craft. What was once an abnegation of the 'niceties of drawing style' has now been adopted as another stylistic schemata. While 'dumb lines' might have once superseded the gestural mark as indicative of its contemporary anti-aesthetic, they are currently deliberately used and self-consciously applied. So what might constitute innocent simplicity now? The innocent simplicity that was once a mark of expressive immersion is difficult to achieve. Work by artists such as David Shrigley appears to be a more contemporary equivalent: playfully meandering around a subject and watchfully self-reflexive.

Drawing does provide an opportunity to escape traditions of both mode and language. But it is contradictory: it both denies, and in some respects confirms, current thinking and trends. In general, drawing can be seen as particularly suited to contemporary aesthetic assumptions as its

characteristics are typically poststructural: uncertain, defiantly idiosyncratic, marking specific difference rather than aspiring to universal values, stubbornly refusing resolved forms, and incorporating the principle of erasure — the will to unmark. It is unstable, and balanced between abstraction and representation; its virtue is its fluidity. Rather than finding refuge in escaping conceptualism or critique, as one might expect of a process that courts the 'dumb line', it typically embraces them. Thus trends can be interpreted variously. Catherine de Zegher states that Avis Newman's suspicion of authorship as ego (and thereby expression) leads her to select from the Tate Collection on the basis of an 'act of consciousness, the manifestation of which is culture and by extension the social, and political realm'.[11] Emma Dexter identifies the characteristics of contemporary drawing as 'anecdotal and narrative potential, its inherent subjectivity, its leanings towards the popular and the vernacular', and the ideal nature of drawing as a form of expression that can resist traditional conventions.[12] At the same time, and in contradiction, its immediacy and directness forces drawing to be authentic and thereby resist one of the foundational premises of postmodernism: the continuous exchange between authenticity and its copy. What Dexter refers to as drawing's 'eternal incompletion', and its obvious expression of difference as an essential feature, perhaps explains its re-emergence.

As art practice assumes an ever-increasing range of technological possibilities, it is natural that there emerges in tandem its anti-form — a simplicity of technology. We are not advocating this as preferable per se; in fact, we embrace the idea of technology that 'draws'. But we are also intrigued by the kind of thinking that drawing facilitates once it relinquishes its inheritance of the three recurrent and associated principles of 'primacy', perception and academic rigour. We approach a drawing from the point of view of its discursive, desultory nature, of what and how the drawing performs and speaks, and of how it explores its subjects. For this reason we have avoided the inclusion of drawings that embrace technologies beyond the simplest (pen, ink, pencil, charcoal, graphite, etc.), so that we can leave aside discussion of any particular medium and instead focus on what results from the drawing process. Drawing is most commonly associated with the imitation of how the visual world is perceived — its visual appearance. As a 'primary means of symbolic communication', it mediates between the metaphysical and the physical, or relating thought and perception. But since drawing refers both to what is seen and to what is thought, the distinction between the objective and the subjective can be conflated and confused. This introduction treats the subjective nature of drawing as primary, and relates it to the objective nature, rather than inserting the subjective and expressive mark in the primacy of objective trace. Having once referred to the unique qualities of drawing, we attempt to avoid repeating statements about drawing as a language that occupies a place/space/time that no other art form can. We attempt to avoid the debate concerning 'what drawing *is*' and the particular properties that define it. However, that this has proved impossible confirms something about the nature of drawing; the intrinsic properties in making a mark are contingent with its making and effect, and central to an argument for subjective and conceptual drawing.

Two parallel discussions about drawing persist: one of appearance and perception, which is assumed to ground drawing's essential properties, and one of conception. Much of the published writing on drawing privileges the former. For example, we identify two directions prompted by Petherbridge's seminal text: one that confirms drawing's link to 'primal processes', enabling objective configurations, and one that perhaps relates to a point before that — a pre-perceptual mode more allied to thinking. This book focuses on the latter, identifying drawing as an ideal means to parallel thinking; it is not viewed as a means to an end, as in preparatory drawings, but as a more conceptual or subjective condition. There are two premises for conceiving drawing that differentiate modes of imitation. The first relates to perception and to the habitual modes of mimesis that imitate appearance via observation. The second relates to thinking: the rational and the aesthetic concept. It is this point, where perception meets conception, that focuses the discussion.

Jacques Derrida's contradictory metaphor of blindness is used to centre this discussion. This is because, in the context of seeing and drawing, blindness disturbs the assumption that drawing must transcribe observation. Derrida's text *Memoirs of the Blind* suggests a number of ways to escape a series of predictable avenues. The text accompanies an exhibition of drawings from the Louvre Museum[13] and takes blindness (and sight) as a central metaphor for the phenomenon of vision and themes relating to it: the visible and the invisible, seeing and drawing, representation, tracing, copying, imagining (seeing in one's mind), remembering and forgetting, whether in memories or memoirs. Drawing circulates around vision and seeing, whether it is literal vision or the psychic vision of dreams and the imaginary. Derrida's discussion addresses the two considerations of drawing; the first is concerned with its abstract dimensions, and the second with the way in which we, as drawers, engage

with the world. 'Blindness' articulates the impossibility of imitation — blind to the world, drawing what is seen and not seen, with and without seeing. The quotation at the start of this introduction suggests a number of central ideas that drawing amplifies: drawing as the visualisation of thought; drawing's dependence on vision and its relationship with perception; drawing as *trait*[14] — the manner in which it imitates the world; drawing that depends on an inner vision; and drawing as a reflective process. One cannot draw without (hind)sight, memory or consciousness of resemblance. Derrida's exploration suggests that at the heart of this dependence on vision is the contradiction of seeing, of tracing an imitation, of re-presenting, which is embodied in the physicality of the act of drawing and the drawing itself. This is the contradiction between the will to imitate and the will to invent, to escape convention, to break the rules. Sight is understood as an equivalent to understanding and knowing ('I see'). Thus, if we deny sight as a means of making reference, we can only access understanding at the point of making the mark, and drawing the drawing. We can understand drawing as conjecture at the point of perception and at the point of remembering, for one can only appraise a memory once it is represented (drawn). Borrowing some of the terms and questions raised by Derrida, we pursue the idea of drawing as the 'hypothesis of sight',[15] of intuition and conjecture, and contend that drawing, as a contemporary operation, makes propositions and hypothesises. We focus on the 'thought of drawing', which emphasises its potency as residing in its ambivalent qualities — its propensity to speculation and its contradictory condition.

We have subdivided our discussion into sections. 'Playing with Appearance' considers the inheritance of perception and possible alternatives to it: first, the differentiation between modes of imitation (perceptual and behavioural), and second, the differentiation between modes of operation (behavioural and conceptual). 'The Thought of Drawing' considers what is meant by the nature of concept. We chase down something other than a drawing dependent on perception, something that avoids the dualism of reality and appearance. Instead we look at a series of oppositional conditions that occur in drawing and in responding to drawing: appearance and disappearance, memory and amnesia, performance and stasis, the visible and the invisible, transcendence and immanence. 'Hypothesis of Sight' returns to the differentiation between the ontological (what drawing essentially is) and the discursive (how it thinks). Here we concentrate on the implications resulting from drawing considered as thought and concept and dependent on the process of its making — its performance.

playing with appearance

Drawing works to abolish the principle of Disappearance, but it never can, and instead it turns appearance and disappearance 'into a game' [which] can never be won, or wholly controlled, or adequately understood.[16]

John Berger's discussion emphasises the *act* of drawing, as 'becoming rather than being',[17] which suits our focus on 'doing', discourse and 'drawing as thinking'. Berger distinguishes between three types of drawing: those concerned with observation, with communicating ideas and with memory. He argues that 'Each type of drawing speaks in a different tense' that requires 'a different capacity for imagination.'[18] His reference to 'tenses' implies that drawing is a verb operation (doing) and introduces a useful premise from which to start. In addressing the action of drawing he demonstrates that the second two forms (ideas and memory) are impossible without at least the *memory* of observation. While we are not concerned primarily with drawings that grapple with observation, we must acknowledge the relationship that ideas and memory have with observation. A drawing collates images from a variety of sources (memory, fantasy etc.), so any drawing that involves reference to the visible necessitates the illusory craft of drawing 'as if' in front of the scene. Drawing moves between observation, studying the visible (the present tense), reference (past and memory) and projection (future tense and what is absent). The artist (characterised here by Tracey Emin's work) '"restores" invisibility to memory', making visible what is 'unbeseen'.[19] It is memory and anticipation that organises what is perceived, that projects beyond what is present and rescues the repetitive interruption of the 'gaze in the batting of an eyelid'.[20] Drawing plays with appearance; it oscillates between seeing, thinking, remembering and imagining, controlling and being controlled as the image emerges.[21] It is continuously and simultaneously shifting itself in the course of its making.

Berger's attempt to categorise the complex procedures of drawing illustrates an inherent contradiction in both 'objective' and 'subjective' drawing. He confirms that 'every drawing is drawing by memory', so that what is remembered saturates both the other modes (observation and ideas). Thus, subjective drawing must rely on the memory of observation, and memory filters observation and directs imagination with inherited value judgements. That is why it takes so long to learn.[22] If drawing was transcription, a kind of script writing,

it could be taught with little effort. In its discussion of John Tchalenko's research, Andrew Graham Dixon's television series *The Secrets of Drawing* (2005) illustrates the role played by learning in terms of how to transcribe what is seen in the Western tradition. Dixon's attempts to draw, compared to the conventions of Sarah Simblet's, highlight the underlying values provided by experience.[23] The same episode, with Dixon informing the viewer about the life class as he stands next to the 'model', captures succinctly the irony, prejudice and assumption contained in Berger's first category of existential observation, with its focus on vision and what we see as a mirror to our consciousness.

Drawing's association with the illustrative imitation of appearance derives from the interrelationship of art and representation with the science of perception. The history of painting demonstrates its inheritance from Plato's notion of original essence and its relation to the world as dependent on imitation of the phenomenological (visual) world. Plato's dialogue proclaims that mimesis, generally interpreted rather literally as imitation and translated visually as realism, relies on little more than 'a mere phenomenal appearance' of a thing rather than the *use* or *experience* of a thing. Plato points out that appearance depends on the perspective from which something is viewed and is thereby incidental to what is being described: 'Isn't it merely that it *looks* different without *being* different?'[24] Alternatively, there are subjective forms of representation which do not assume that appearance above all else signifies meaning, but which instead forefront knowledge, experience or use of whatever is drawn. The history of visual representation in painting shows us the shift from a pre-Renaissance mode of reality, which describes a subjec-

tive *knowledge* of the substance of the world (e.g. visualised in symbolic pictorialism), to one that represents our *perception*, which promotes the possibility of objectivity. 'Seeing' incorporates inherited ideas about the world, which influence the particular manner of representation. Those who have taught objective drawing will recall pointing out the difference between what we see, the appearance before us, the attempt to apprehend it uncorrupted by our understanding of it, and our knowledge and understanding of the object and its use. The child who draws a table's four legs splayed out from each corner understands that a table needs four legs for it to function as a table and that this might be more important than its appearance.

The legacy of mimesis (as copy) rests heavily with drawing — the compulsion to draw a likeness tends to take precedence. But representation can incorporate other modes of the mimetic faculty besides the compulsion to imitate appearance. We can consider reality as being experienced through senses other than vision. There are alternative ways of mimicking reality in imitating behaviour and process, making sense of experience and rendering it concrete. Jean Fisher's essay 'On Drawing' describes the conflict (and contradictions) between wonder, convention and learning. She aptly identifies the misrepresentation of drawing as a function of perception 'in which the coordination of hand and eye supposedly aims for "objective" realism' in imitation of the visible. She suggests that drawing represents a different sort of mimesis, as 'pure invention of an anamnestic return',[25] that points to kinds of experience other than the visual:

Like being caught up in the rhythm of a dance or a jazz ensemble, or mesmerized

by the intonations of a poetic reading, the act of drawing dismantles consciousness and plunges the self into a zone of experience or sensation liberated from the closures of representation and open to the free play of possibilities. Thus the drawing is the expression of this libidinal movement, free of signification and interpretation.[26]

Gebauer and Wulf's discussion of mimesis explains its reduction to appearance as being an inadequate interpretation of reality, one that neglects a more 'active and a cognitive component'.[27] It is assumed that the mimetic faculty is a natural process, but the dominance of vision in Western culture quickly constrains its potential. Walter Benjamin, confirming our 'compulsion to become and behave like something else', suggests that the 'mimetic faculty' as an instinct emerges more behaviourally, such as in the acquisition of language through imitation (e.g. 'woof woof'), or in the imitation of an inanimate object such as a train.[28] He questions habitual conceptions of mimesis that are dependent on the visual illusion of physical appearance, and emphasises forms of mimicry that determine our individual development, our singularity and difference, and which form the basis of social interaction and behaviour.

What we are chasing, in terms of the manner and process of contemporary drawing, introduces a form of cognitive mimesis that operates mindfully and speculatively (as Shrigley's drawings do for example), and recalls Plato's assertion of a kind of knowledge of reality that is not dependent on objectivity or observation. But while Plato's distinction between the 'ideal form' of the object and its copy separates a concept from its dependence on appearance, it does not recognise or value visual ideas unless they are conceived as

'essential' or 'ideal'. Much of the drawing in this book, rather than seeking any ideal or universal quality, relies on the idiosyncratic and, even, the anti-ideal. It is this aspect that is 'dumb' rather than the quality of the line, which can now only be knowingly drawn.

Avis Newman's discussion of drawing as a 'theatre of gesture' suggests that it presents the point at which something that wasn't there before is made manifest. This is not necessarily the same as the imitation of an ideal. Like Fisher, Newman likens drawing to the animation of thought, and promotes a focus on drawing as process by emphasising its primary function of thinking, considering the activity to be simultaneous with language and not coming before or after.[29] However, in this conception of drawing, it remains a responsive sort of thinking. Newman's premise rests more with the spontaneous — drawing as a response to what is seen, which mediates between vision and hand. What of the more subjective and deliberate? How does contemporary drawing utilise or abandon its received tyranny of language?

Pursuing Newman's contention that drawing equates with thought, we can look at this in terms of the subjective, the conceptual and the performative. Leaving observation aside, we look at drawing as a mediating representation that derives from experiences other than visual perception. We look more closely at drawing as an alternative means to imitate experience and to conceive realism. Much of the work in *Drawing Now* abandons the resort to appearance, presenting instead the use or experience of something. We focus on those drawings that do not attempt to trace the visible, but rather seek to experience what is not visible — the invisible, or the 'unbeseen'.

the thought of drawing

Outline drawing, where detail is suppressed or subjugated to the containing and defining contour, is the most conceptual means of drawing. It is the most abstract, in that to arrive at a clarity of outline is a process of reduction and deliberate simplification and stylisation.[30]

Petherbridge's statement provokes the question: in what sense can drawing be conceptual? It assumes that the reduction occurs during the analytical process of looking that takes place in 'objective' drawing, by which objects are reduced to nonexistent lines, whereas describing 'subjective' ideas or delineating a conception is a synthetic process. If drawing visualises thought, as is suggested by numerous commentators (including Fisher and Newman), its actual visualisation is presented alongside its twin facility of (drawing) likeness and appearance. The fact is that once we animate thought, we must give appearance to it — visualisation anticipates resemblance and provokes recognition. Drawing is contradictory in its dependence on the memory of observation while conceiving a world that does not rely on the existence of essential form or objective perception. Although it is not bound to conform to representing ideational form, it readily facilitates speculative ideas; it has the postmodern characteristics of self-conscious reference and mannerism while inevitably, and in contradiction, inviting ideational drawing. One prevalent trend, represented here by Angela Eames and Jonathan Houlding among others, depicts imagined spaces that rely on the most traditional of drawing systems for their realisation.

Having stated an emphasis on conceptual modes of drawing, we need to clarify what we mean by the terms 'concept' and 'conceptual'. Since these terms were adopted by conceptual art, they have been modified and confused. Conceptual art has amplified the contradictions between mimesis and concept that operate in drawing. In the 1960s, the processes of meaning associated with conceptual art promoted exchange between the uses of language and images and questioned the apprehension of a work of art as being dependent on mimetic reference. Sol LeWitt presented a version of art that placed the idea and the visual as being interdependent, where the process of conception and the process of visualisation are of equal importance. Joseph Kosuth, in questioning aesthetic formalism, posited that the idea itself can be considered as art, shifting the emphasis from the material and the visual to the conceptual content — a shift from looking to reading.[31] It is the holding-function of concept, motivated by artistic context and its reliance on visual play, which propels the concept beyond the notion that it is limited to verbal thought or that it is standard or limited in number. However, conceptual art has come to be associated with dry, visual-less art, whereas the term itself refers to the cognitive operation in apprehending meaning. We focus on this original emphasis of cognitive over specular response.

LeWitt makes the distinction that it is the idea (the components) that implicate the concept (general direction).[32] The term 'idea', which Berger uses, is not straightforward, and can be generalised or contradictory, allied as it is to 'mental image' and 'representation', or confused by associations with 'seeing' in the sense of understanding. Historically, 'ideas' have been linked to our perceptions — to what is seen rather than what is experienced, or again in turn to a kind of idealism. The difficulty with the term 'concept' (a thing conceived, an

idea, a general notion) is that it is applied to a variety of mental representations: images, words, senses, properties and philosophical functions. 'Concept' is confused by its use as a term to designate what is referred to when any *word* is used, while drawings do not confine meaning to what is designated by words and encompass ideas that may not be articulated by language. It is *Western* linguistics that contains knowledge in arbitrarily assigned characters that represent sounds, rather than in pictograms that contain a cluster of concepts within one image. The principle of designation, of naming, therefore underlies any discussion that is concerned to understand the conceptual nature of drawings and how they perform meaning besides what is drawn — their subject matter. Thus, a more suitable interpretation of 'concept' is a 'cluster of capacities',[33] rather than something definitive. Conceptual thinking in drawing promotes an inability to define. Drawing can be a particularly ambiguous form of representation, and the term 'concept' is useful *because* it is ambiguous and accesses networks of meaning, thinking and being (objects/entities/dispositions/capacities). There are clearly different strains of 'concept' and its more precise meaning must therefore rely on the theoretical context in which it is used — in this instance drawing, which accesses 'concepts' via visual figuration. Just as a word attempts to identify a meaning or thing, a drawing circumscribes meaning and things. Drawings are aggregations that can only *refer* to what things look like; 'naming' objects that we recognise is not how we respond to a drawing. It is a more complex process of seeing, thinking, relating and remembering. As we have suggested, the recognition of fragments goes beyond the designation of appearance to something more like an

understanding of their function and our previous experience.

Looking for an explanation of 'concept' beyond the correlation between a word and its meaning, Gottlob Frege's explanation is useful in its adjustment of the emphasis of designation.[34] Using the nominal expression 'Dobbin is a horse' as an example, he suggests that 'is a horse' works not as a reference or a name, but as a description that is applied to what is being described, i.e. Dobbin. Thus 'is a horse' signifies the concept of being a horse rather than signifying 'horse' as an object. This is the central point — the emphasis is on circumbulatory description rather than designation. When we describe, we 'have' a concept that remains vague until it is articulated verbally, when it begins to find form and moves towards a definition. As soon as it is articulated it becomes established as a named and recognisable thing, whereas before the 'concept' was unformed and formless, not a subject or any one thing. Frege's notation distinguishes between reference to one thing (in this instance Dobbin) and the sense designated by the expression that describes it. His logic extends the idea of a single nominated element to that of a set of properties or attributes rather than one thing. This approach understands an image as more than an alignment with words, but as a 'cluster of capacities' and a conceptual configuration. Freges's concept as description rather than definition approaches what happens when looking at a drawing, indicating the inference inserted by all things not said, but expressed in other ways — the sense of an expression, which is apprehended more intuitively by the way to which it is referred, rather than to what is referred. References may thus have many 'senses' indicated by the way they are expressed within the drawing — the *how* of expression (i.e. the manner of

its making and the resulting marks), rather than the *what*. Drawings think around a subject; they are discursive. As aggregates of experience, they can only suggest and refer to 'reality' or appearance. Similarly, when looking at a drawing, we search for possibilities that match our experience.

Many of the properties referred to in the analysis of literary metaphor (the process of substitution, where meaning shifts from one domain to another more unfamiliar one) can be applied to the processes involved in understanding imagery. George Miller's analysis proposes that in making sense of a text (an image), we construct 'semantic models' as alternative possibilities of meaning.[35] Applying this notion to what happens when we look at a drawing enables us to conceive the possibility of one situation *and* its opposite or absence simultaneously, so that different elements may be incompatible and even contradictory. George Lakoff's 'contemporary theory' supports a conceptual system of meaning that operates outside language. Lakoff proposes that what we call 'metaphor' is the main mechanism through which we comprehend abstract concepts and '[map] across conceptual domains'.[36] His theory explains what Derrida describes as disseminated meaning, which remains fragmented, multiple and dispersed, as opposed to gathered together and totalised.[37] The operation of 'semantic models' supports a conception of meaning that does not have to be logical, and the notion of a conceptual framework extends the possibility of conception beyond the thing or entity.

Following this procedure, and liberated from the need for a supposed universal property or access to 'truth' behind appearance, meaning can work in a way that allows a number of possibilities or 'models' to inhabit an image. Visualisation of a concept, because it uses appearance to trigger

recognition, assumes by default the notion of 'likeness' and the degree of 'truthfulness' understood in that likeness. But, as we make connections between properties and qualities, concepts, in the sense that they are capacities, are only required to accumulate likenesses, not resolve them. Derrida's thinking about supplement similarly maps a framework for exploring the image that covers all eventualities within the field. It works much like a figure-field switch, in which the peripheral becomes necessary and central at the same time as being an addition. A common attribute of drawing is the embedding of concept within the physical property of the materials used, as in the work of Cornelia Parker.

The processes of representation by concept and imagination are discussed by Immanuel Kant, who articulates the key relationships between understanding and imagining, between what is demonstrable and what is not, between what is explicable and what is not. His distinction between 'rational ideas' and 'aesthetic ideas' clarifies what might be understood as two categories of conceptual drawing. He speaks of 'rational ideas' as elements that form an understanding of something in an objective (rational) sense, so that a 'concept of understanding' is demonstrable and graspable. The drawings of Paul Noble, Erwin Wurm and Simon Evans can be seen as 'rational' ideas that demonstrate another space or map another dimension, and are visualised as measurable and graspable; they are *speculative*. Kant describes an 'aesthetic idea' as distinct from 'concepts of understanding', as 'that representation of the imagination which induces thought, yet without the possibility of it being in any way definitive or adequate to it, and which language consequently can never get quite on level terms with or render completely

intelligible.'[38] An 'aesthetic idea' is an intuition (of the imagination) and is subjective. This mode of thought is not representable but relies, in this context, on the process of drawing itself. Its whereabouts cannot be located; one cannot say for example 'here is the frivolity' or 'here is the source of my disturbing response'. We might say that an 'aesthetic idea' emerges in a sensation that is more visceral than visual, as with the work of Anne-Marie Schneider or Monica Weiss. In these terms we have the difference between an aesthetic idea that follows the subjective principle and cannot be explained, and rational ideas that are rationally explicable or visually illustrate concepts such as magnitude or structure using objective principles (i.e. schemata). We might have an idea, so conceived that we cannot imagine it nor demonstrate it entirely as it resides in the relationship between imagination and understanding, and possibly *exceeds* understanding and can only be approached through the physical process itself. John Willats distinguishes between elements such as lines within a drawing (what he calls 'picture primitives') and the marks made — the way that they are drawn: their capacity to be expressive, their 'sound'.[39] This distinction echoes the difference between drawing that relies on drawing systems to create another world and drawing that relies on the nature of application rather than what is drawn, as is evident in an obsessive process of drawing (e.g. Brian Fay or Marco Maggi) or in the physically explosive (e.g. John O'Connell). Such a physical engagement with the drawing process moves away from depiction to something that indicates a complexity which it is not possible to fully depict. These are the two forms that many of the drawings in this book occupy, and which show us the contradiction inherent in visualising what cannot be seen either by speculation (e.g.

Noble) or effect (e.g. Weiss). It is a difference expressed in practical terms by Alyson Brien as 'a problem between drawing what I know would be physically there if I created this shape and what you would be able to see if you were looking at it and I'm torn between drawing it as if it's made of glass and drawing the way in which from one side this would be obscured.'[40]

hypothesis of sight

I feel myself incapable of following with my hand the prescription of the model: it is as if just as I was about to draw, I no longer saw the thing. For it immediately flees, drops out of sight and almost nothing of it exists; it disappears before my eyes, which in truth, no longer perceive anything but the mocking arrogance of this disappearing apparition.[41]

Derrida's assumption about drawing in *Memoirs of the Blind* is one of looking and copying and concerns the conflation of the fleeting certainty of sight with the imitation of what can be seen. But his speculation on blindness works as an extended metaphor for several dimensions of the act of drawing both from observation and imagination — the thinking operation in the process of drawing and the reflection process in its reading. The act of drawing is fascinating in the way that it struggles to translate experience, particularly experience besides that of the appearance of objects. Without representation, which requires definition of some sort, experience remains continuous, ambivalent, incomprehensible and irretrievable. Temporality is not grounded in anything unless we ground it by relating it to concrete things, and it only becomes past, present or future in relation to ourselves. Philosophy circulates around notions of what consciousness is: what is me and what is not, what is out

there and how I can understand it, how I relate to it and how is it related to me, and the difference this makes to my experience and understanding. Conscious experience relies on our imagination to anticipate and remember at every instant, making sense of sensory input. As we make sense of experience, we separate certain elements of the perceptible from others that we do not 'see' but are inseparable from those we do. Thus we experience space and time as a series of modified possibilities or snapshots. Similarly abstract ideas (and drawings) must separate attributes or functions from others in this way.[42] In translating experience of the world into a manageable form, elements of the experience are changed or lost and, just as verbal translation loses dimensions of experience and is constrained by previous explanations that confine its context, so too is drawing. Drawing, as a means of explaining an experience, conflates events or separates instants into a described whole. In its effort to explain and translate, no drawing will do justice to what is lost. As soon as one thought is articulated, another is lost, and every point of significance identified makes it less likely that we will find other possible points. There remains an enormous difference between what is seen and what is understood, and again between what is drawn and the drawing itself. In its effort to delineate, drawing *is* contradiction.

At the instant when the point at the point of the hand … moves forward upon making contact with the surface, the inscription of the inscribable is not seen. Whether it be improvised or not, the invention of the *trait* does not follow, it does not conform to what is presently visible … Even if drawing is, as they say mimetic, that is reproductive, figurative, representative, even if the model is presently facing the artist, the *trait* … escapes the field of vision.[43]

Derrida's descriptions of the act of drawing utilise several physical operations as analogies: the blinking of an eye, the movement of the hand, touching the paper and drawing the line. They play on associations of the hand in correspondence with the eye, with specific little gestures and pressures, and, on examination, probing, adjusting and mending: 'drawing as surgery'.[44] Juliet McDonald similarly, but visually, illustrates the hand in the process of drawing as metonymically standing in for the whole person (e.g. fumbling, gripping, grasping) and as significantly invoking the attributes necessary to assert control in drawing (e.g. naming, signaling, pointing, manipulating).[45] The use of the line as a model represents the complexity that interweaves seeing, conception and convention. It allows us to understand what is ultimately obscure, by describing a physical concrete experience, so that more elusive experience is explained by its analogy with 'line' and its appearance on the paper. At the moment at which the point (of the pencil) makes contact with the surface, we cannot see (literally or figuratively) what is about to emerge, and yet the point anticipates the memory of what has been seen in the past: it both stops and anticipates what is to come. The act of drawing 'escapes the field of vision' even as it copies, because the line is not yet visible and because its conception remains beyond the reach of objectivity. Derrida's reference explains objective drawing as contradictory in its blindness, and subjective drawing as a fundamentally contradictory condition. The correlation of drawing with blindness illustrates a contradictory logic that somehow makes sense in a process that watches itself arrive.

Drawing always signals toward this inaccessibility, toward the threshold where only the surroundings of the *trait* appear …The outline or tracing separates and separates itself; it retraces only borderlines, intervals …The linear limit I am talking about … divides itself in its ellipsis … In this twinkling of an eye, the ellipsis is not an object but a blinking of the difference that begets it … through which, *between* which, you can observe without being seen, you can see between the lines.[46]

Derrida's description of what happens at the point of drawing a line is a kind of metaphysics of drawing, an analogy that correlates the physicality of the hand and the line at the point of touching the paper to the transcendental. Derrida's reverie recalls his discussion of the internal experience of thought as being radically discontinuous and accommodating an intrinsic multiplicity and mobility. Drawing, as if in dialogue with itself, similarly follows a pattern of realising appearances moment by moment, tracing a series of discontinuous thoughts, from which emerge some recognisable elements. Derrida speaks of the outline as liminal divisibility that interrupts itself and becomes 'inaccessible in the end, at the limit.' As such, it can only retrace the borderlines of an instant and, in reaching beyond its limit, disappears. Ruminating on the sort of 'knowledge' we encounter in the realm of drawing, as he does in 'Cartouches', the 'linear limit' refers to what is left out, erased or aborted and suggests that both erasure and destruction manifest the ephemeral and the ambivalent. Invisibility, at the point of erasure, represents the performance of metaphysics. Just as Marvin Jordana's hypothetical, linear forms hover around something nearly recognisable, and almost describe objects but not quite, so the 'linear limit' neither speaks of ideals nor of what is intelligible or can be wholly interpreted — it only indicates the difference between one form that remains unformed and

another.[47] As with the psychoanalytic process that strives to uncover meaning, but no *one* definitive meaning, the 'scene of drawing' simultaneously obscures and reveals, and elides all interpretations. Ultimately Derrida uses the act of drawing as a vehicle to illustrate elusive and contradictory concepts. Brien's description, recorded *as* she draws an unformed concept (an 'aesthetic idea'), echoes the oscillation between seeing, thinking and imagining, and parallels Derrida's abstract commentary in practical terms:

> I'm rubbing out some lines I've previously put in . . . in little pecking gestures — to get the rubber to get rid of the marks I've already put on, which is not that easy . . . better . . . there are some other lines that I don't want that I'm also taking off that are too thick and too . . . in the wrong place — that's them coming off . . . a bit more . . . here's a pale grey I've got here that I put on before — I'm covering over what I did . . . adding to it . . . Again I'm moving the chalk round and creating a growing light grey area — moving it out from the centre around into an area I've previously drawn . . . make it darker and slightly more . . . curved . . . trying a fanning out idea . . . adding some other areas with the darker areas in . . . there's a form appearing but its very unclear what's happening to the edges — its splitting like a banana . . . out — I don't know if that's what I want but that's what's happened.[48]

Brien's self-absorption demonstrates the process of drawing as an extreme immersion in reaction and anticipation. Her description confirms two things: that the performative process of drawing is liminal, moving between conscious decision and unconscious compulsion, and that it incorporates a synthesis of addition and subtraction. It is notable that Brien spends as much time removing marks as she does putting them on and that 'removal marks' become just another kind of additional mark

in the construction. The process of subtraction and addition in the physical act of drawing touches on the difference between what is seen and what is conceived, and again between what is conceived and what appears on the paper. The process refers, via subtraction, to what is absent as well as present to description. While Brien has an 'idea' of what she wants, she avoids being too clear in advance of the action. As she draws, she recognises what it is she wants or doesn't want. Her 'ideas' are movements and qualities, not definitive things. It's quite clear that she is driven by what happens on the paper and that to a great extent she is not the one in control. She expresses surprise several times at what is happening in front of her, as if independently, and uses words like 'coaxing' as though persuading the drawing to do what she wants, but at the same time acknowledging that it won't necessarily. It is evident that the inherent blindness in looking is inextricable from the mechanics of thinking, and that the act of drawing a line illustrates the point at which the ontological meets the conceptual. Conceiving drawing as a conceptual operation that hypothesises incorporates the physical emergence of line at the point at which visual appearance disappears and conception appears. Derrida and Brien each articulate the interdependence of conception with the physical process. Each repositions drawing with its production as a particular form of thinking that cannot be separated from its peformance: it is performative thinking.

The performance of drawing (Berger's 'doing') reacts to a succession of disturbances: the procedure of addition and erasure, of gesture and change, of instinct and thought. What the performance implicitly tells us is that the drawing process enacts a simultaneous physical contradiction that, as Katrinka Wilson determines,

is a transaction between appearance and thought.[49] The term 'performance' can sometimes indicate a mimetic representation that suggests a passive operation where the participant actualises something already determined. Whereas it is shown above to be more (re)active, drawing here demonstrates process and idea simultaneously in the course of its own production. And the one who draws both directs their own form of production and is directed by the drawing. J.L. Austin describes a 'performative statement' as referring to itself in the process of its own making.[50] A performative statement declares its own doing as in 'I am drawing', as opposed to a 'constative statement' that is already defined before it is said. Austin's distinction between 'performative' and 'constative' statements provides an interesting analogy for drawing, both in terms of the procedure itself, and in terms of the differentiation between what might be termed a 'constative' drawing, which would represent or describe mimetically, and a 'performative' drawing, which can be seen as changing its own terms, as it performs itself. In 'doing' drawing, a drawing is seen to constitute itself; the drawing is more event than thing. The performative, discursive drawing incorporates the physicality of process and the function of addition and subtraction.

Benjamin's definition, which describes drawing as ceasing when a line is no longer distinguishable from its background, refers to a static, one-dimensional record of appearance.[51] The drawings collated in this book focus on what can emerge from speculative activity, an operation not dependent on sight and imitation, but on what is happening, being felt and being thought. Drawing here is an active and imaginative performance, a place of demonstrative production rather than a tool of neutral translation.

introduction

As a discursive exploration, drawing is first performative and only second a product, demonstrating a switch of emphasis from the dominance of visual appearance towards a consideration of drawing as an interactive dynamic and as a space of conception and speculation.

This collection of drawings emphasises the interdependence of what drawing is (its physical nature) and the way it conceives ideas (thinks). To clarify the confusing application of the term 'conceptual', we recalled Kant's attempt to differentiate processes of representation and have appropriated his 'aesthetic ideas' and 'rational ideas' to suggest two modes of conceptual drawing. These terms serve to articulate two different approaches seen here — one that demonstrates the drawer's immersion in the activity of drawing and is typically *performative*, and one that demonstrates a more rational application of the imaginary and is *speculative*. We emphasise conceptual operations that encourage a range of possibilities (semantic models) or that generate an extended form of description, focussing on the functions associated with what something does ('is a horse') or how that something is experienced, rather than the definition of that something as a static object. This understanding of the conceptual encourages an open-ended interpretation that suits the questioning nature of many of the drawings here. Both modes depend on the remnants of visual perception, require the interdependence of cognitive imagining with its subsequent visualisation, and encourage a cognitive operation beyond that of purely speculative pleasure. As we have seen, subjective drawing relies on at least a memory derived from observation, and thus both these modes incorporate all three of Berger's categories simultaneously: observation, ideas and memory. What might

be termed 'conceptual drawing' encourages a journey around associative thought that does not have to be logical or resolved, provokes an aggregation of memories and impedes access to any resolved meaning. Are conceptual drawings theoretical, abstract, intangible or ambiguous? They can of course be all of these things, but tend to be either of two modes: aesthetic, intangible, ambiguous and sometimes abstract, or rational, theoretical and sometimes abstract. The extent to which drawings demonstrate the degree of signature and expression depends on which of these two 'ideas' are engaged.

We emphasise the performance of drawing as forcing a discursive outcome that is ambiguous in appearance or speculative in its content, and the ontology of drawing as being more discursive than perceptive. Discursive drawing 'thinks' in characteristic ways. Derrida's suggestion of the 'thought of drawing' as hypothesis explains its capacity for contradiction, for if one hypothesises, one tests the extremities of possibility and conducts experiments. Drawing hypothesises; it demonstrates oppositional conditions and proposes concepts that are neither proved nor disproved, neither true not false. They are 'let's suppose' or 'what if?' exercises. The 'thought[s] of drawing' do not describe or report and cannot be verified. The question of their being factual or truthful is inappropriate.

As hypotheses, drawings are, by definition, contradictory, and we have found several points of contradiction that are characteristic. First, this is apparent in their stylistic independence and versatility. Because of its practical application across a range of contexts, drawing readily appropriates, for example, the various styles of academia or the language of the functional diagram; it accommodates specific differentiations, idiosyncrasy (e.g. Hauptman) and self-reflexivity

(e.g. Shrigley). Drawing can provide a neutral territory that allows its perpetuation as a classical tradition, but more interestingly it is also recognised as a process that can escape traditional and fashionable constraints. By definition, drawing is forced to follow its own limitations and strengths — the place of performance where thought meets the commitment to paper. We note that the conflict between the compulsion to copy, seen as a 'natural' instinct, and the compulsion to invent what is not there, produces an oscillation between imitation and invention. We notice the many contradictions shared by observational drawing and imaginative visualisation. Both trace what is only momentarily visible, literally and conceptually. Drawings recall both what was there (absence) and what could be there (invisibility), and in the drawings collected here we can see that the dominance of perception is relinquished and memory and its extension in imagination takes precedence. Drawing has proceeded from the 'primal means of communication' to a procedure that facilitates the more directly theatrical in its artifice or its physical engagement.

Emergent themes in this collection could be described as 'Another Place', 'Unbeseen', 'Play', 'Reflection', 'Performance' and 'Sensation'. When figurative, the drawing here recollects the experience of sensations other than vision (e.g. Schneider, Emin). When it appears to tell a story, it is a conditional speculation, clearly not of this world (e.g. Woodfine), or it plays cognitive games (e.g. Cambre). When delineating space in recognisable form, it is of another fantastical place. The use of line is often simple and unpretentious, lacking signs of gestural expression, less ambiguous than speculative, less abstract than conceptually questioning. The 'dumb line' is playfully and humorously reflective (e.g. Shrigley, Evans, Jeff Gabel),

but not simply innocent. And when the line is obsessive, it challenges the premise of drawing's flatness as illusional space, and is made real (e.g. McKenzie, Locke, Bowlby). The 'tyranny of language' can be seen to incorporate a self-conscious lack of respect for the more academic. It has assimilated an eclectic mix of schemata derived from a range of drawing traditions, both 'high' and 'low'. The 'totality' of image has given way to an acceptance of the means of making (its performance) as a subject itself rather than a process towards something.

Proposing the need to establish a clear agenda for drawing research, Steve Garner states: 'Just how drawing supports cognitive processes, particularly creativity and the emergence of ideas, has been discussed but little evidence has been used to construct a foundation of knowledge on which we might build.'[52] Contrary to the will to define what drawing is, the nature of drawing appears to inhabit an area that facilitates a level of ambiguity and a dynamic that promotes non-definition and the non-conclusive. Drawing 'aesthetic ideas' demonstrates the capacity to describe just those qualities that may be indescribable and which contradict those aspects of research that attempt to understand the cognitive process. In exploring drawing's metaphoric capacity, our manner of examination here reflects the *experience* of cognitive mimesis rather than a scientific appraisal of its effect. Further investigation might or might not benefit from a more scientific approach to understanding the cognitive nature of the artistic operation of drawing. There are several research projects in the fields of cognitive psychology and artificial intelligence where, for example, physical testing and cognitive analysis are applied with the aim of understanding drawing and spatial reasoning — how we learn and interact.[53] The agenda

for research in the area of fine art might seem to be at odds with such developments. But as drawing's dynamic depends on the cognitive operation and because of its (sometimes deliberately exploited) elusive qualities, the drawing process provides exactly the ambiguous arena that might challenge scientific methodology. The peculiar act of drawing illustrates the dichotomy between knowledge, self-consciousness and intelligence and the desire to respond to a reality beyond that of appearance. *Drawing Now: Between the Lines of Contemporary Art* explains drawing as a representation of experience rather than appearance, and in this sense relinquishes the mantle of perception. The realm that the drawings in this book explore is not so much the visible as the invisible.

endnotes

1 Derrida, Jacques, *Memoirs of the Blind, the Self Portrait and Other Ruins*, trans. Pascale-Anne Brault and Michael Naas (Chicago and London: University of Chicago Press, 1993). Derrida uses the terms 'thought of drawing', p. 3, and 'between the lines', p. 55.

2 Ginsborg, Michael, 'Preface: What is Drawing?', in Kingston, Angela (ed.), *What is Drawing? Three Practices Explored: Lucy Gunning, Claude Heath, Rae Smith* (London: Black Dog Publishing, 2003), p. 11: 'Paper is not the only support for drawing but it is by far the most widespread. Drawings are made with graphite, charcoal, chalk, or ink with brush and pen. Drawing is flat and monochromatic and it does not predominantly address colour relationships.'

3 De Zegher, Catherine (ed.), *The Stage of Drawing: Gesture and Act, Selected from the Tate Collection* (London; New York: Tate Publishing and the Drawing Centre, 2003).

4 Belting, Hans, *The End of the History of Art*, trans. Christopher S. Wood (Chicago: University of Chicago Press, 1987), cited in Danto, Arthur C., *After the End of Art, Contemporary Art and the Pale*

of History (Princeton: Princeton University Press, 1997), p. 5.

5 For example Baudrillard, Jean, 'Starting from Andy Warhol', in Lotringer, Sylvere (ed.), *The Conspiracy of Art: Manifestos, Interviews, Essays*, trans. Ames Hodges (New York: Semiotext, 2005), pp. 43–9.

6 Petherbridge, Deanna, *The Primacy of Drawing, An Artist's View* (exhibition catalogue, A National Touring Exhibition from the South Bank Centre, 1991), p. 7.

7 Newman, Avis, 'Conversation: Avis Newman/ Catherine de Zegher', in de Zegher, *The Stage of Drawing*, p. 235.

8 Bryson, Norman, 'A Walk for Walk's Sake', in de Zegher, *The Stage of Drawing*, p. 155.

9 Bryson, *The Stage of Drawing*, p. 153.

10 Petherbridge: *The Primacy of Drawing*, p. 52

11 De Zegher, *The Stage of Drawing*, p. 276.

12 Dexter, Emma, *Vitamin D, New Perspectives in Drawing* (London: Phaidon Press, 2005), p. 9.

13 The exhibition 'Memoirs of the Blind' was held from October 1990 to January 1991 and was the first in a series entitled 'Taking Sides', which invited 'personalities known for their critical abilities' to initiate a discourse prompted by their choice of drawings.

14 Derrida's use of the word *trait* contains a range of meanings – trait, feature, line, stroke, mark, which are discussed in depth by Michael Newman, 'The Marks, Traces, and Gestures of Drawing', in de Zegher, *The Stages of Drawing*, pp. 93–108.

15 Derrida, *Memoirs of the Blind*, p. 60 ff. For the most part Derrida proceeds to discuss the hypothesis of sight in relation to self-portrait, which does not concern us here.

16 Elkins, James, letter to John Berger [2004], in Berger, John, *Berger on Drawing* (Aghabullogue, Co. Cork: Occasional Press, 2005), p. 112.

17 Berger, 'Lobsters and Three Fishes', in *Berger on Drawing*, p. 124.

18 Berger, 'Drawing on Paper' [1996], *Berger on Drawing*, pp. 46 and 47.

19 Derrida, *Memoirs of the Blind*, p. 45: 'The draftsman always sees himself to be prey to that which is each time universal and singular and would thus have to be called *unbeseen* . . .'.

20 Baudelaire, Charles, 'Mnemonic Art', in Mayne, Jonathan (ed.), *The Painter of Modern Life and Other Essays* (London: Phaidon Press, 1964), pp. 15–18. Derrida references Baudelaire in *Memoirs of the Blind*, pp. 48–9: 'For Baudelaire it

is the *order of memory* that precipitates beyond present perception the absolute speed of the instant (the time of the *clin d'oeil* that buries the gaze in the batting of an eyelid).'

21 De Zegher writes of the oscillation between the imagined and the concrete in her discussion concerning 'abstract', where language as the symbolic (covering the gap between the real and the imaginary) became an obsession in semiotics and psychoanalysis and was understood to bring a conditional order to the chaotic and unthinkable of the world by standing for an imagined structure: Catherine de Zegher, 'Abstract', in de Zegher, Catherine and Hendel Teicher, *3 X Abstraction New Methods of Drawing Hilma Klint, Emma Kunz Agnes Martin* (New York: The Drawing Centre New York; Yale University Press, 2005).

22 Berger, John, 'Janos Lavin's Diary', extract from *A Painter of Our Time* [1958], in *Berger on Drawing*, p. 102.

23 Graham-Dixon, Andrew, 'All in the Mind', *The Secrets of Drawing, Episode 3* (BBC, 2005). John Tchalenko's 'Drawing and Cognition' SciArt project at Camberwell College of Arts examines eye control, maps the movement of the artist's eyes when drawing with the help of biomedical tools and techniques and suggests that the artist's knowledge may help medical processes.

24 Plato, *The Republic* (London: Penguin Books, 2003), pp. 340 and 339.

25 Fisher, Jean, 'On Drawing', in de Zegher, *The Stage of Drawing*, p. 220.

26 Fisher, 'On Drawing', p. 217.

27 Gebauer, Gunter and Wulf, Christoph, *Mimesis, Culture: Art: Society*, trans. Don Reneau (Berkeley, Los Angeles, London: University of California Press, 1992), p. 5.

28 Benjamin, Walter, 'On the Mimetic Faculty' [1933], in Jennings, Michael, Eiland, Howard and Smith, Gary (eds), *Selected Writings Volume 2 1927–1934*, trans. Rodney Livingstone (Cambridge, MA, London: Harvard University Press, 1999), p. 720.

29 Newman describes a particular kind of knowledge peculiar to drawing in 'Conversation Avis Newman/Catherine de Zegher', pp. 231–7.

30 Petherbridge, *The Primacy of Drawing*, p. 32.

31 Kosuth, Joseph, *Art After Philosophy and After: Collected Writings, 1966–1990* (Cambridge, MA, London: MIT Press, 1993).

32 LeWitt, Sol, 'Sentences on Conceptual Art' in Alberro, Alexander and Stimson, Blake (eds), *Conceptual Art: A Critical Anthology* (Cambridge, MA, London: MIT Press, 1999).

33 Honderich, Ted (ed.), *Oxford Companion to Philosophy* (Oxford, New York: Oxford University Press, 1995), p. 146.

34 Derrida explains confusions between the two (Frege's *Sinn* and *Bedeutun*) in *Speech & Phenomena* (Evanston, IL: Northwestern University Press, 1973), pp. 18–19, specifically the difference between Husserl's and Frege's uses. 'Sense' is confused in translation and it is significant to note that Derrida's use of 'meaning' ('sens' and 'vouloir-dire') incorporates the French sense that literally means 'will to say' and which includes the understanding of purpose, intention in its foundation. His manner of language not only contributes to what might seem contradictory definitions of the term, but can deliberately incorporate contradiction. In discussing distinctions with reference to Husserl, he distinguishes between meaning (*bedeuten*) and sense (*Sinn*), which he refers to as 'the pre-expressive form of sense' and notes that where the two may become fused, it becomes impossible to distinguish between 'the stratum of sense and the stratum of meaning'.

35 Miller, George A., 'Images and Modes, Similes and Metaphors', in Ortony, Andrew (ed.), *Metaphor and Thought* (Cambridge: Cambridge University Press, 1993).

36 Lakoff, George, 'The Contemporary Theory of Metaphor', in Ortony, *Metaphor and Thought*, p. 203.

37 Derrida, Jacques, *Positions*, trans. Alan Bass (Chicago: University of Chicago Press, 1981), pp. 61–2.

38 Kant, Immanuel, 'Analytic of the Sublime', §49, in *The Critique of Judgement*, trans. James Creed Meredith (Oxford: Clarendon Press, 1952), p. 175, and 'Dialectic of Aesthetic Judgement', §57, Remark I, pp. 209–13.

39 Willats, John, 'The Syntax of Mark and Gesture', 2002, in *TRACEY: Contemporary Drawing Research* (http://www.lboro.ac.uk/departments/ac/tracey/somag/willats.html).

40 Brien, Alyson, 'Thinking Through Mark and Gesture', 2002, in *TRACEY* (http://www.lboro.ac.uk/departments/ac/tracey/somag/brien.html).

41 Derrida, *Memoirs of the Blind*, p. 36.

42 Urmson, J.O., in Parkinson, G.H.R. (ed.), *Encyclopedia of Philosophy* (London: Routledge, 1988). p. 119.

43 Derrida, *Memoirs of the Blind*, p. 45.

44 Derrida, *Memoirs of the Blind*, p. 5.

45 McDonald, Juliet, 'Out of Hand', in *TRACEY* (http://www.lboro.ac.uk/departments/ac/tracey/narr/index.htm).

46 Derrida, *Memoirs of the Blind*, pp. 54–5.

47 Derrida, Jacques, 'Cartouches', in *Truth in Painting*, trans. Geoff Bennington and Ian McLeod (Chicago, London: University of Chicago Press, 1987), p. 209, and *Memoirs of the Blind*, p. 54.

48 Brien, 'Thinking Through Mark and Gesture'.

49 Wilson, Katrinka, 'Mimesis and the Somatic of Drawing: In the Context of 20th Century Western Fine Art Practice' (PhD thesis, Loughborough University, 2004).

50 Austin, J.L., *How to Do Things with Words* (Cambridge, MA: Harvard University Press, 1962).

51 Dexter, Emma, *Vitamin D, New Perspectives in Drawing* (London: Phaidon Press, 2005), p. 6, citing Benjamin, Walter, 'Painting, Signs and Marks' [1917], in *Selected Writings, Volume 1* (Cambridge, MA: Harvard University Press, 1996), p. 83.

52 Garner, Steve, 'Towards an Agenda for Drawing Research', 10 November 2006 (www.jiscmail.ac.uk/archives/drawing -research .html).

53 For example the 'Drawing and Cognition' project (John Tchalenko, Camberwell College of Art) or 'Notation and Cognition in Conceptual Sketching: An Analysis of the Graphical Notation of Visual Reasoning in Design' (Jeanette McFadzean and Nigel Cross, the Open University) or Whale, George A., 'An Investigation of Spatial Strategy in Observational Drawing' (PhD thesis, Loughborough University, 2005).

the artists

Anna Barriball was born in 1972 in Plymouth, England and studied at Winchester and Chelsea Schools of Art. Her selected solo exhibitions include Walsall Art Gallery (2006), Arnolfini, Bristol (2003), Gasworks Gallery, London, and Newlyn Art Gallery (2005). Barriball's work is included in the British Art Show 6 and featured in Phaidon's *Vitamin D*.

Nayland Blake was born in 1960. He is an artist, writer, curator and educator, and currently lives in Brooklyn, New York. His work is included in numerous collections. He prefers to work in Staedler graphite pencils.

Astrid Bowlby was born in Bath, Maine and now lives and works in Philadelphia. She has exhibited widely since 1994; her most recent solo exhibition was entitled *A certain density* and exhibited at Gallery Joe, Philadelphia. She has work in numerous collections, including the Philadelphia Museum of Art. In 2007 she was awarded a Pennsylvania Council on the Arts Fellowship.

Julie Brixey-Williams is a British artist who lives and works in London. Her work explores the relationship that the body shares with space and architecture, using movement and gesture to explore traces.

Javier Cambre was born in San Juan, Puerto Rico and currently lives and works in New York. Engaged with video, sculpture, photography and drawing, Cambre has exhibited his work throughout the world. He is Professor of Drawing and Graphic Design at QCC, City University of New York.

Louise Clarke is an artist, curator and passionate advocate of drawing in its widest application. She has exhibited extensively around the world, including at an art residency in Kyoto, Japan and a drawing symposium at Nitra, Slovakia (both 2006). Her recent public art programmes include *Big Draw* at the British Museum, and events at the Victoria & Albert Museum and English Heritage.

Cullinan + Richards artlab is the collaborative partnership of Charlotte Cullinan and Jeanine Richards. They live and work in London. Their artist-run space 'The Savage School Gallery' opened in October 2006. Recent projects include *Headquarters* at the Daniel Spoerri Sculpture Garden (2006) and *Retrospettiva*, Pari Dispari Projects, Reggio Emilia, Italy (April 2006).

Angela Eames states that her drawing asks the question: 'Where and what is drawing now?' She considers drawing to be a visual thought process, and uses it to explore potential, and the implications this has for technology. She is interested in rethinking the position of the viewer and the viewed.

Jacob El Hanani was born in Casablanca, Morocco in 1947. In 1969 he attended the Avni School of Fine Arts, Tel Aviv, Israel, and continued his studies at the Ecole des Beaux-Arts, Paris in 1970. He lives and works in New York City. His focus lies with accretions of finely drawn mark-making that form fields of meditative harmony.

Tracey Emin was born in London in 1963. Her selected solo exhibitions include the Stedelijk Museum, Amsterdam (2002); Haus der Kunst, Munich (2002); Modern Art Oxford (2002); Art Gallery of New South Wales, Sydney (2003); and Platform Garanti Contemporary Art Center, Istanbul (2004). In 1999 Emin was shortlisted for the Turner Prize, and in 2007 she represented Britain at the Venice Biennale.

Simon Evans was born in 1972. He lives and works in London.

Brian Fay is an artist and Lecturer in Fine Art at the Dublin Institute of Technology. His work is concerned with recording time and dialogical references across media. He is a member of the Artists Panel at the Irish Museum of Modern Art and a board member of Visual Artists Ireland.

Christoph Fink was born in Gent, Belgium. His recent exhibitions include *Presentation of the integration of a work of art* at the Netwerk/Centre for Contemporary Art, Aalst, Belgium (2007) and *Outdoors* at Danielle Arnaud Contemporary Art, London (2006).

Julia Fish is Professor in the School of Art and Design at the University of Illinois, Chicago. She has exhibited widely and has work in museums and public collections, including the Art Institute of Chicago, Los Angeles Museum of Contemporary Art, and the Museum of Modern Art, New York.

Maryclare Foa is concerned with drawing in response to the environment. Leaving temporary trace marks on, in and around the environment, she intends her interaction to bring a momentarily visual slippage, which renews interpretation of the space and offers the audience alternative connections and associations.

Jeff Gabel grew up in Decatur, Nebraska and currently lives and works in Brooklyn, New York City. He received a BFA at Kansas State University and an MFA at Pratt Institute. Gabel shows with Spencer Brownstone Gallery in New York City.

Jane Harris was born in Dorset in 1956 and lives and works in London. She was educated at Goldsmiths College, the Slade School and Brighton Polytechnic. She has work in numerous collections, including the Arts Council of England and Birmingham Museum and Art Gallery. Her international exhibitions include Los Angeles, New York and Stuttgart.

Susan Hauptman studied painting at Wayne State University in Detroit. She presently holds the Lamar Dodd Professorial Chair at the University of Georgia in Athens. Her works are in several private and museum collections, including the Metropolitan Museum of Art, the Corcoran Gallery, the Norton Gallery of Art in Palm Beach, Florida, the Arkansas Art Centre, the Oakland Museum in California, the Detroit Institute of Art, the Minnesota Museum of Art, and the California Palace of the Legion of Honour.

Andy Hewitt and Mel Jordan have been collaborating since 1999. Their practice is concerned with the discourse around art's social potential and its relationship to public space and the public sphere. Their recent projects include (with Dave Beech) the Second Guangzhou Triennial, China, curated by Hou Hanru and

Hans Ulrich Obrist; *London in Six Easy Steps*, curated by B+B, Institute of Contemporary Arts, London; and (with Dave Beech) *The Aesthetic Function*, curated by Gavin Wade, for the fifty-first Venice Biennale.

Jon Houlding was born in 1972, and graduated from the Royal College of Art in 2005. He is now a practising artist living and working in London.

Dean Hughes was born in 1974 and studied at Chelsea College of Art and Design, London. His recent exhibitions include *Doggerfisher* in Edinburgh; *Living Dust* at Norwich Gallery; and at the Jack Hanley Gallery, San Francisco. He lives and works in Manchester.

Benoît Jacques was born in Brussels, Belgium in 1958 and studied at the
Royal Academy of Art, Brussels and the Ecole Nationale Superieure of Visual Arts, Cambers. He lives and works in France.

Marvin Jordana was born in 1971 in Naga City, the Philippines, and currently lives in Los Angeles, California. Since 2004 he has had exhibitions in Houston, Texas, including *Art Star Houston*, *Downtown Stomp Around*, *Project Row Houses*, *Buffalo Bayou Xmas Tree Show* and *Artcrawl Houston*. He exhibits regularly in various and random parts of Los Angeles at his own volition.

Naomi Kashiwagi was born 1982 in Halifax, and now lives and works in Manchester. Her Fine Art studies at Manchester Metropolitan University included exchanges to Venice and Tokyo. She has exhibited in the UK, Italy and Finland. Her exhibitions include *Notions of Drawing* at CIP House, London; *Duet* at the British Art Show Sideshow, Nottingham; and Nationwide Mercury Art Prize, Air Gallery, London (2005).

Hew Locke studied at Falmouth and the Royal College of Art. His earlier works include brightly coloured papier maché sculptures, and highly textured charcoal drawings that rework the fine art traditions of European masters. He explores global cultural fusions, creating complex sculptural reliefs made of market-stall mass-produced toys, souvenirs and consumer detritus.

James [Jim] Madden has moved from studying architecture at the Rhode Island School of Design in 1975, to painting at the School of the Art Institute of Chicago (in 1994) and the University of Iowa (in 1996). His *Castaways* drawings are an exploration of the world of abandoned technology. These outmoded leftovers seem both forlorn and earnest as they continue to sit atop roofs all over the USA.

Marco Maggi was born in Uruguay and is an MFA, University of New York. His exhibitions include *Poetics of the Handmade*, Museum of Contemporary Art, Los Angeles (2007); *Gyroscope*, Hirshhorn Museum, Washington (2006); *Drawing From the Modern 1975–2005*, Museum of Modern Art, New York City (2005); Fifth Gwangju Biennial, Korea (2004); *Works on paper since 1960*, Museum of Fine Arts, Boston (2003); Twenty-fifth Sao Paulo Biennial, Brazil (2002).

Jordan McKenzie is a performance/visual artist whose work interrogates drawing as a performative act. He has exhibited both nationally and internationally and is currently a visiting lecturer at Kingston University and Wimbledon College of Art in contemporary performance practice. Originally interested in queer body-based identity politics, his current research is concerned with drawing and its relationship to iconic minimalist sculpture.

Ming-Hui Chen was born in Taiwan in 1977. Chen has exhibited regularly in Taiwan, Japan and China since the mid 1990s, and more recently she has been invited to exhibit in the UK, including at LCB Depot, Leicester (2005), Lakeside Arts Centre, and Surface Gallery, Nottingham (2006). She is a leading scholar of women's art of Taiwan.

Paul Noble was born Dilston, Northumberland in 1963. His selected solo exhibitions from 1990–2005 include Ye Olde Worke, Cubitt Gallery, NOBSON, Chisenhale Gallery, Albright Knox Gallery, Maureen Paley, Whitechapel Art Gallery, Migros Museum, and Museum Boijmans Van Beuningen. His solo publications include *Paul Noble*, Whitechapel Gallery and Migros Museum; *Unified Nobson*, Newtown, Alberta Press (2004); and *Nobson Central*, Verlag der Buchhandlung Walther König (2000).

John O'Connell is an artist working in sculpture, drawing, film and video. In 2005 he was awarded the Further Film Residency at no.w.here lab in London. His recent exhibitions include the Dublin Darklight film festival, *Magazine* in Edinburgh, *Brazil* in New York, *Peripheral Visions* in Cork and *Archttype* at the Transition Gallery in London.

Cornelia Parker was born in 1956 in Cheshire, England. Her solo exhibitions in the last three years include the Wurttembergischer Kunstverein (Stuttgart), Galleria d'Arte Moderna e Contemporanea (Turin), and ICA (Philadelphia). Parker was nominated for the Turner Prize in 1997. Her work is represented in international collections, including the Tate Gallery (London) and the Museum of Modern Art (New York City).

Charles Poulsen is a sculptor. Drawing on paper is important to him, as he values its immediacy of expression. In 2006 he made a huge drawing on the land by cutting into living heather on the Southern Upland Way. He exhibits widely in the UK and has made work in Germany and the USA.

Matthew Ritchie was born in 1964, and lives and works in New York City. His multimedia installation *The Universal Adversary* was exhibited at Andrea Rosen Gallery, New York City in September 2006. His next major project will be an outdoor pavilion conceived in collaboration with David Altmejd and supported by TBA 21, Vienna.

Annette Robinson lives and works in London. She currently lectures on the BA drawing course at Camberwell College of Art and is part of the newly established drawing research group at the University of the Arts.
She has been awarded two international fellowships, in Norway and France, and has exhibited widely both nationally and internationally.

Ugo Rondinone was born in 1963 in Brunnen, Switzerland and he currently lives and works in New York. He has exhibited extensively throughout Europe and the United States and has work in numerous public collections.

Anne-Marie Schneider, a French artist, was born in 1962. Her exhibitions include *Être un Autre*, Tracy Williams Ltd, New York City (2006); *Vertige*, Le Printemps de Septembre à Toulouse (2005); *Étrangement Proche*, Saarland Museum, Saarbrücken (2004); *Fragile Incassable* at the Musée d'Art Moderne de la Ville de Paris (2003); FRAC Picardie (1997); and *Documenta X*, (1997).

David Shrigley was born in England in 1968. He has exhibited his drawings, photographs and sculptures in galleries and museums worldwide. He is the author of numerous books and over the past five years has started to make animated films. He lives and works in Glasgow, Scotland.

the artists

Barthélémy Toguo was born in Cameroon in 1967, and today lives and works in Paris, Düsseldorf and Bandjoun in Cameroon. He studied at the Abidjan School of Fine Arts, Ivory Coast, the Grenoble Gradual School of Art, France, and at Klaus Rinke Studio at the Kunstakademie in Düsseldorf. Toguo is concerned by art's presence in Africa, and especially in Cameroon.

Stephen Walter was born in 1975 and studied at Middlesex University, Manchester Metropolitan University and the Royal College of Art. He lives and works in London. His work is held in both public and private collections in Europe, including the British Museum; the Houses of Parliament Museum; Deutsche Bank; the Trussardi Foundation, Milan; London Borough of Barnet Public Collection; and The Royal College of Art Print and Drawing Archive. He is currently a Fellow at the Royal Academy Schools.

Monika Weiss was born in Poland and is now based in New York City. She creates environments that relate to the body and to the tension that characterises specific relationships between biology and culture. In her drawings and multimedia installations, which are combined with performance and sound, Weiss explores the physical properties of the act of drawing, with reference to the ancient, medieval symbols, and concepts of the world and the human being.

Sarah Woodfine was born in 1968, and studied at the Royal Academy Schools from 1991 to 1995. Her group shows include *Only Make-Believe*, Compton Verney; *The Real Ideal*, Sheffield Millennium Gallery; and *Drawing Inspiration*, Abbot Hall Gallery. Her recent solo shows include Danielle Arnaud Contemporary Art (2006) and Ha Gamle Prestegard, Norway (2007). In 2004 she won the Jerwood Drawing Prize.

Erwin Wurm was born in Bruck/Mur in 1954. Between 1979 and 1982 he attended both the Academy of Applied Arts and the Academy of Fine Arts, in Vienna, Austria. His work is involved in the liberation of objects from their fields, altering their significance in the process, and appealing visually to both to recognition and alienation.

drawing now

Black Wardrobe
Tape on wardrobe
(2003)

anna barriball

One Square Foot VI *Pencil on paper* (2002)

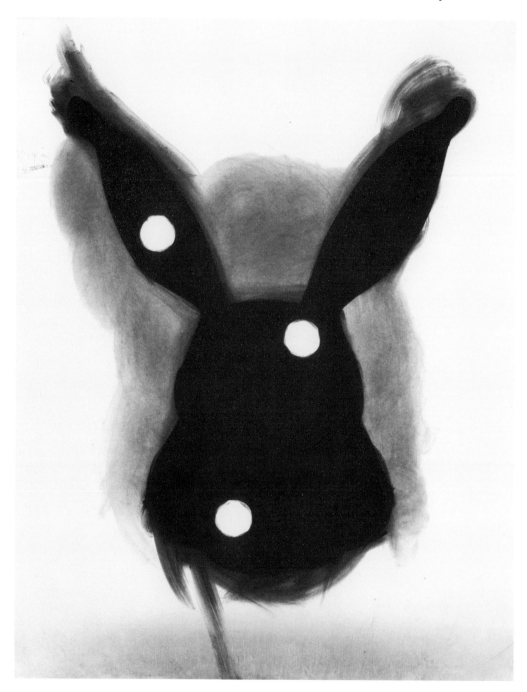

Untitled
Charcoal on paper
(2000)

nayland blake

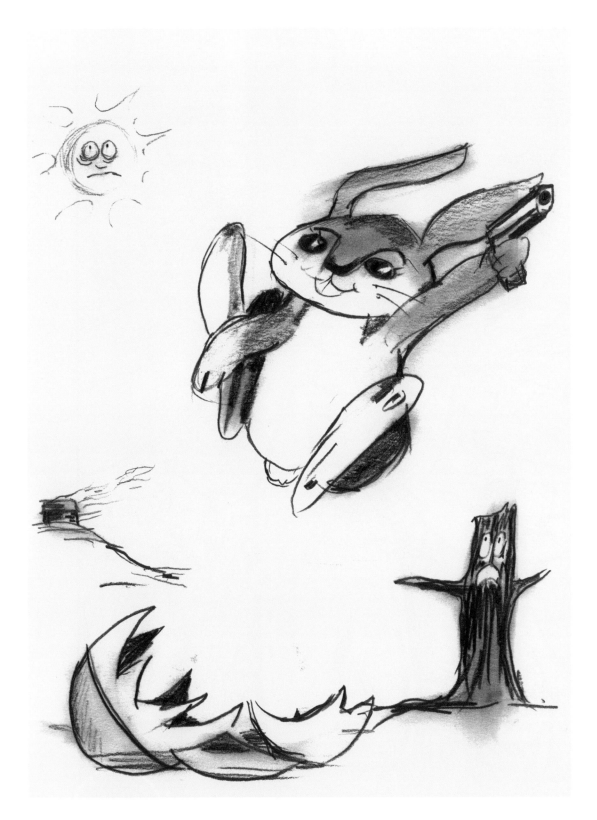

Untitled
Graphite on paper
(2005)

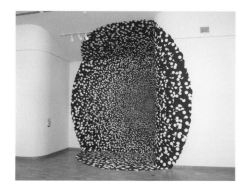

Chrysanthemum 2
Cut paper
(2006)

On Some Far: Detail
Ink on cut paper
(2003)

julie brixey-williams

Locationotation, Deborah 9 Deborah Kay Ward,
in front room, Islington, London N1, 11.30 am on
Sat 9th June 2001
Graphite powder on watercolour paper
(2001)

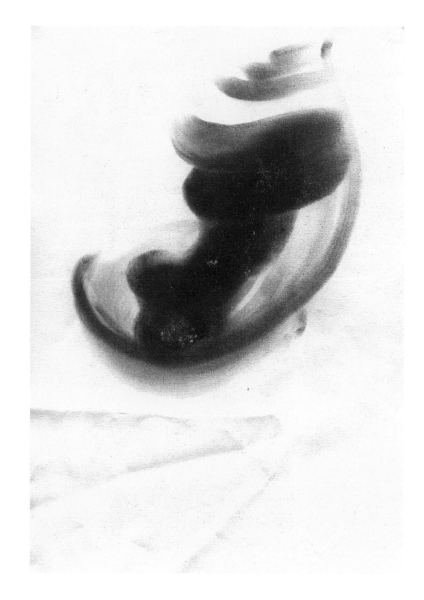

Locationotation, Niki 25 Niki McCretton, on the manager's desk at the
Tacchi-Morris Arts Centre, Taunton, Devon, 11.30 am on Sat 9th June 2001
Graphite powder on watercolour paper
(2001)

Locationotation, Abigail 10 Abigail Salisbury, in Kensal
Green cemetery, 11.30 am on Sat 9th June 2001
Graphite powder on watercolour paper
(2001)

julie brixey-williams

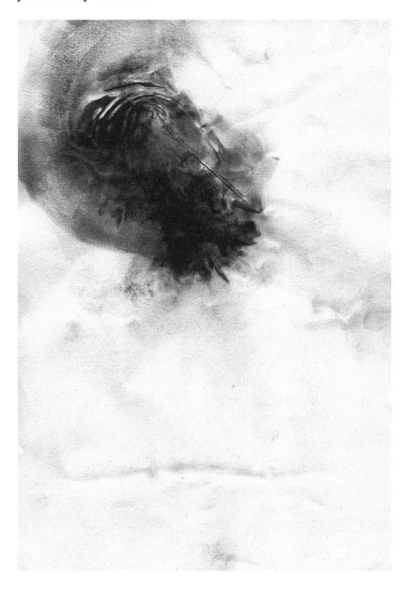

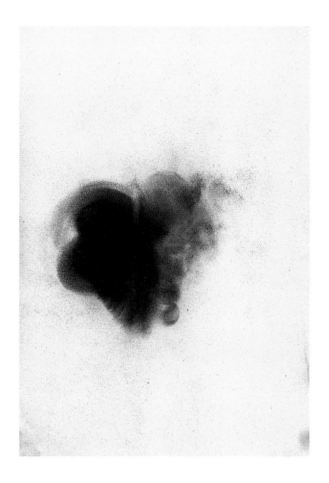

Locationotation, Susan 48 Susan Bowman, on a
tiled floor, in the kitchen, Ealing W13, 11.30 am
on Sat 9th June 2001
Graphite powder on watercolour paper
(2001)

Locationotation, Mel 36 Mel Shearsmith, on grass, inside a bamboo
pyramid next to Clifton Observatory, Bristol, 11.30 am on Sat 9th June 2001
Graphite powder on watercolour paper
(2001)

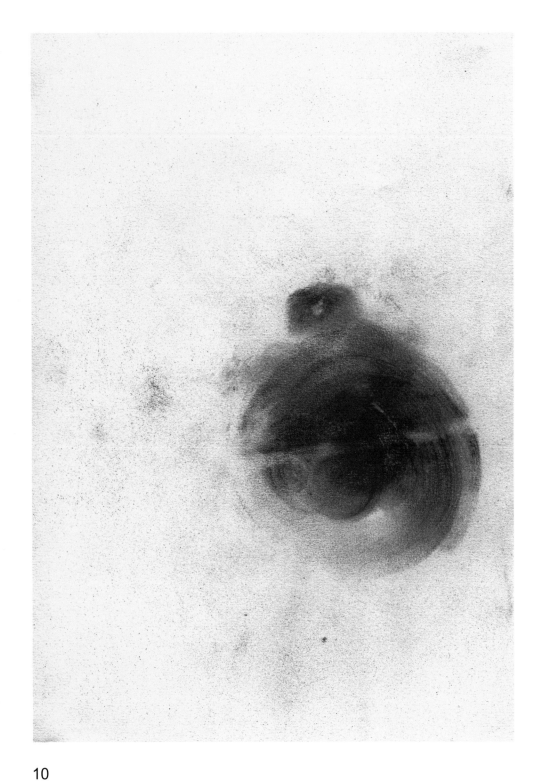

Locationotation, Brenda 50 Brenda Hawkes, on a tiled floor, in the kitchen, Ealing W13, 11.30 am on Sat 9th June 2001
Graphite powder on watercolour paper
(2001)

julie brixey-williams

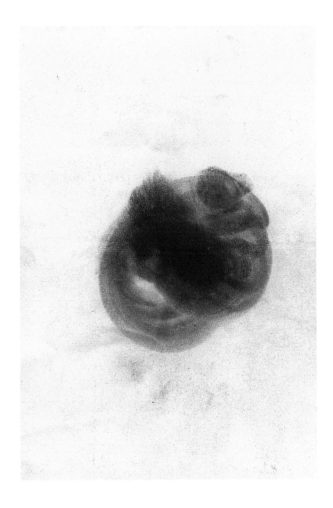

Locationotation, Joe 55 Joe Ballantyne, on the pavement,
by the bus stop, Newham Grange Road, Cambridge,
11.30 am on Sat 9th June 2001
Graphite powder on watercolour paper
(2001)

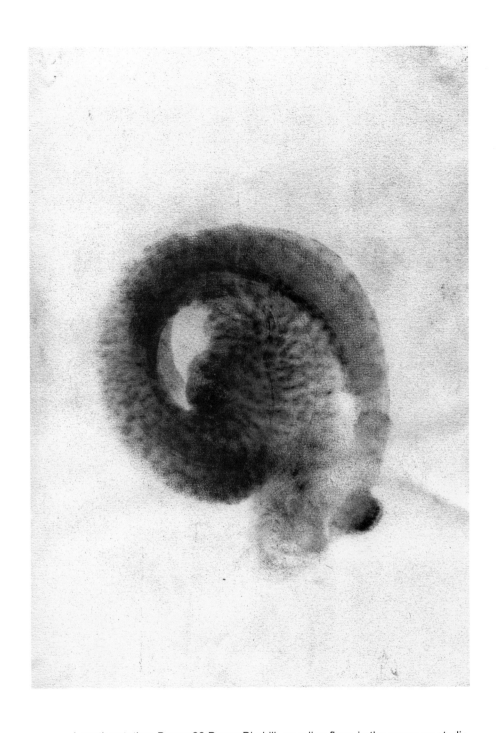

Locationotation, Beccy 60 Beccy Birchill, on a lino floor, in the warm-up studio,
Harbour House, Kingsbridge, Devon, 11.30 am on Sat 9th June 2001
Graphite powder on watercolour paper
(2001)

Another Night in Rented Rooms
Graphite on paper
(2003)

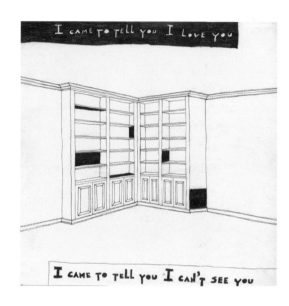

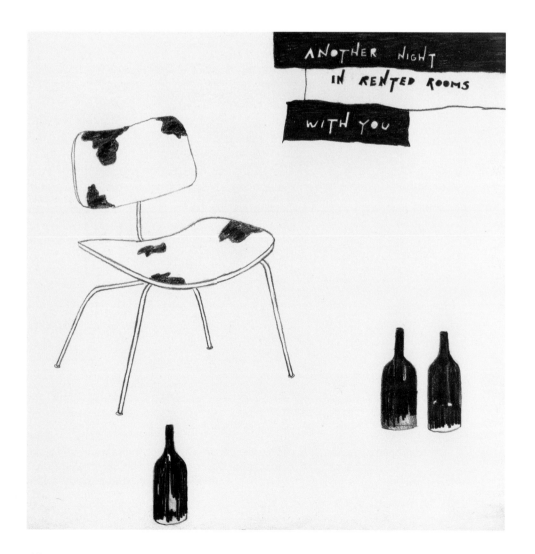

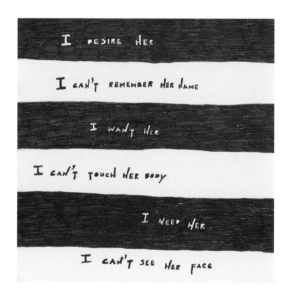

javier cambre

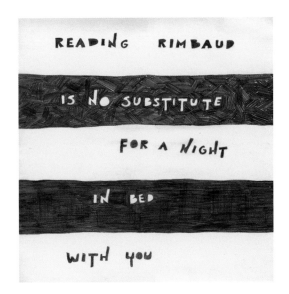

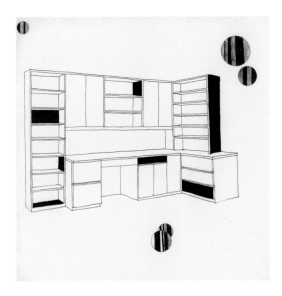

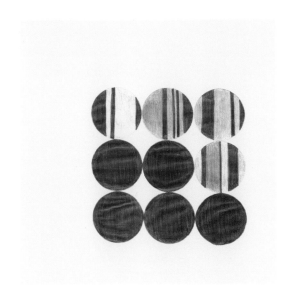

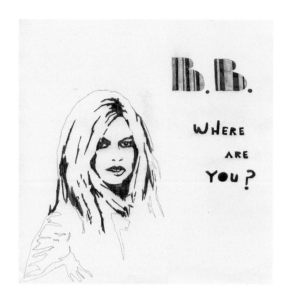

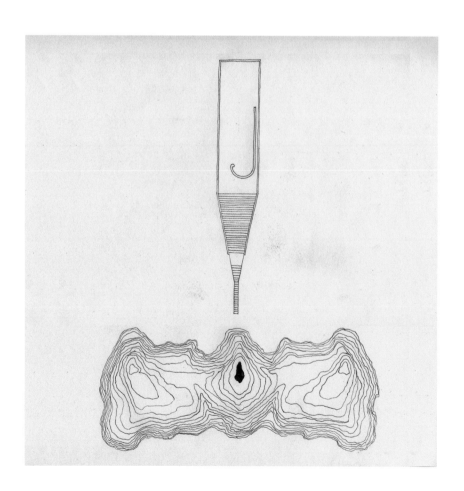

javier cambre

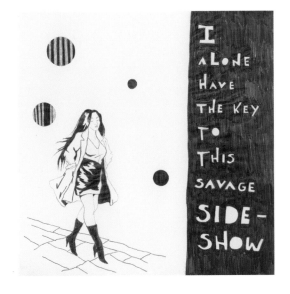

Feather Light
Dip pen and ink
(2005)

cullinan + richards artlab

Savage School Text Type 11 Commemorative
Schematic Drawing C+J Racing Tapestry for
Working Women's Club Bar for Shock Workers
Kent Whitstable Lydden Race Track
Watercolour, felt pen, pencil on watercolour paper
(2006)

Making it up ink
Inkjet print on canvas on stretcher
(2004)

angela eames

Making it up graphite
Inkjet print on canvas on stretcher
(2004)

Making it up biro
Inkjet print on canvas on stretcher
(2004)

angela eames

Making it up charcoal
Inkjet print on canvas on stretcher
(2004)

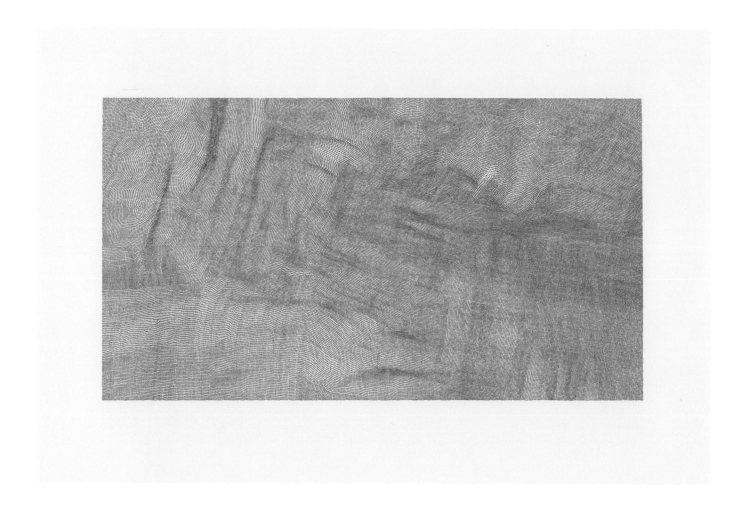

Gauze
Ink on paper
(2001)

tracey emin

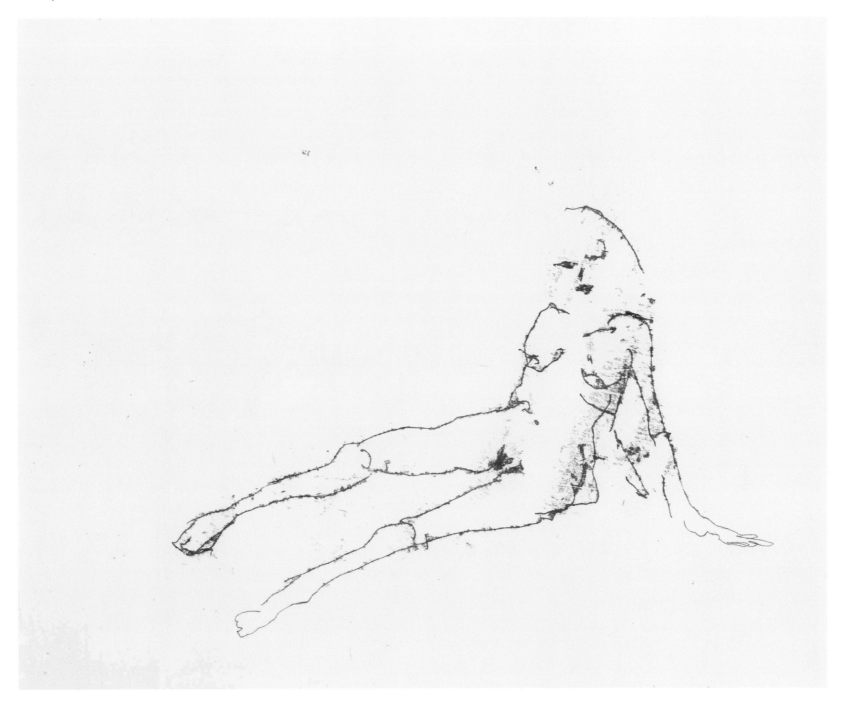

Sexy Dolly *Monoprint on paper* (2005)

Failing at living alone *Mixed media on paper* (2005)

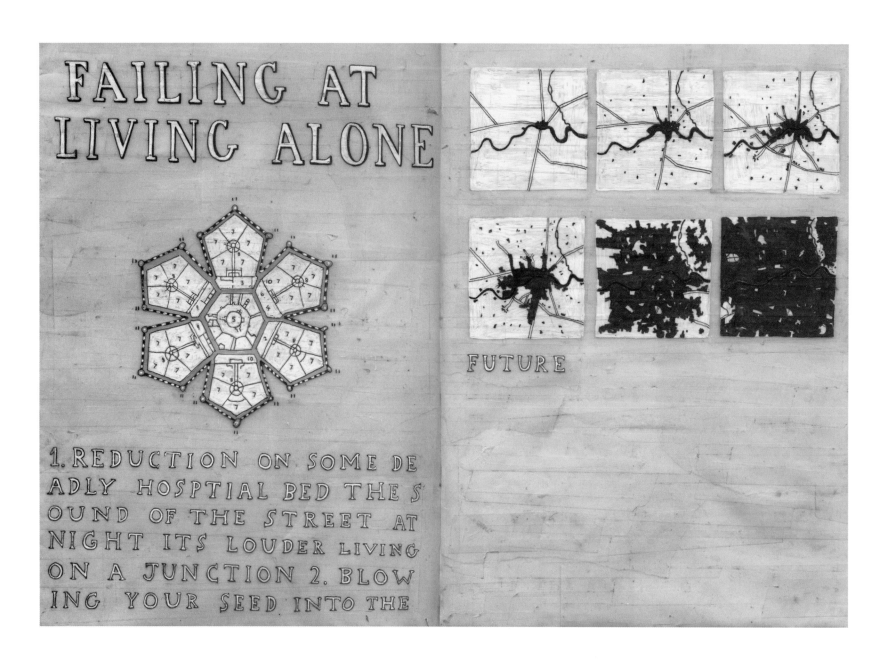

FAILING AT LIVING ALONE

FUTURE

1. REDUCTION ON SOME DE ADLY HOSPTIAL BED THE S OUND OF THE STREET AT NIGHT ITS LOUDER LIVING ON A JUNCTION 2. BLOW ING YOUR SEED INTO THE

simon evans

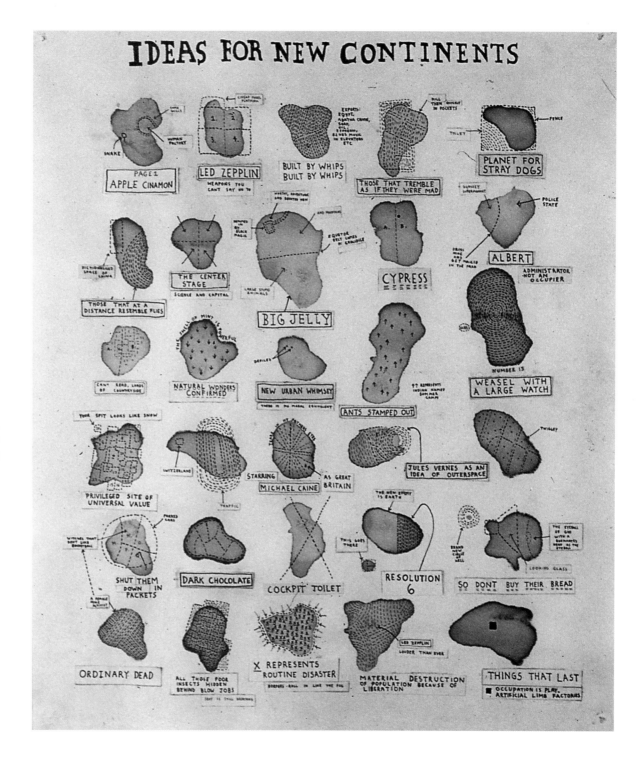

Ideas for New Continents 2004
Mixed media on paper
(2004)

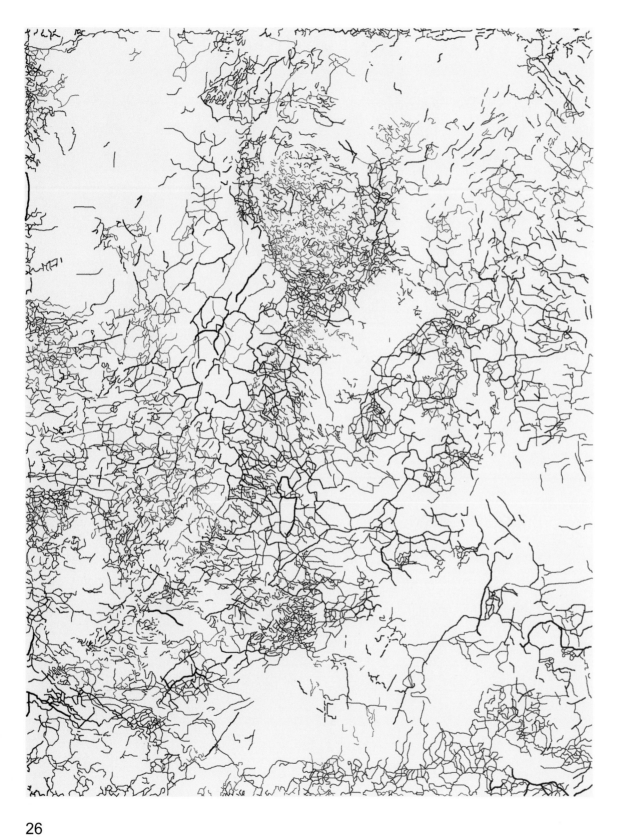

Woman Meditating after Corot
Digital drawing on paper
(2005)

brian fay

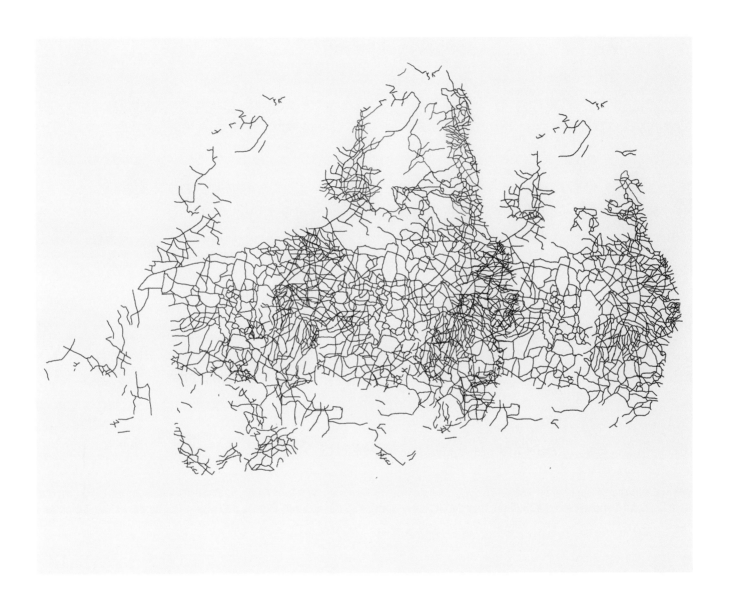

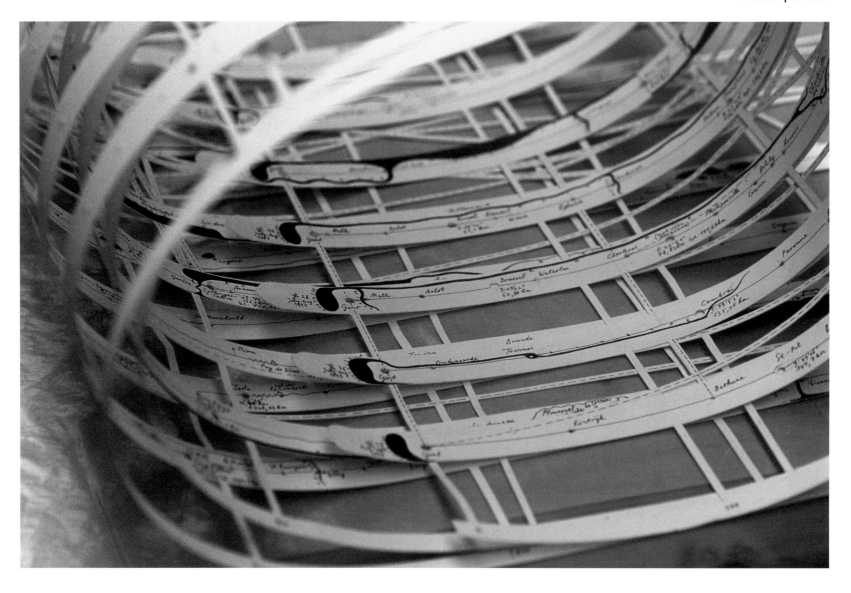

Atlas of Movements, Studies of Continental Europe (bicycle), a selection: movements #6 (Gent-Faro), #7 (Gent-Genève-Zürich-Gent), #8 (Gent-Den Haag-Gent), #12 (Gent-Venetia-Gent), #28 (Gent-tour du Mt Blanc-Gent), #35 (Gent-Etna(-Gent)), #37 (Gent-Pointe de corsen-Grenoble-Genève-Gent)
Blue ink on paper
(2000–3)

christoph fink

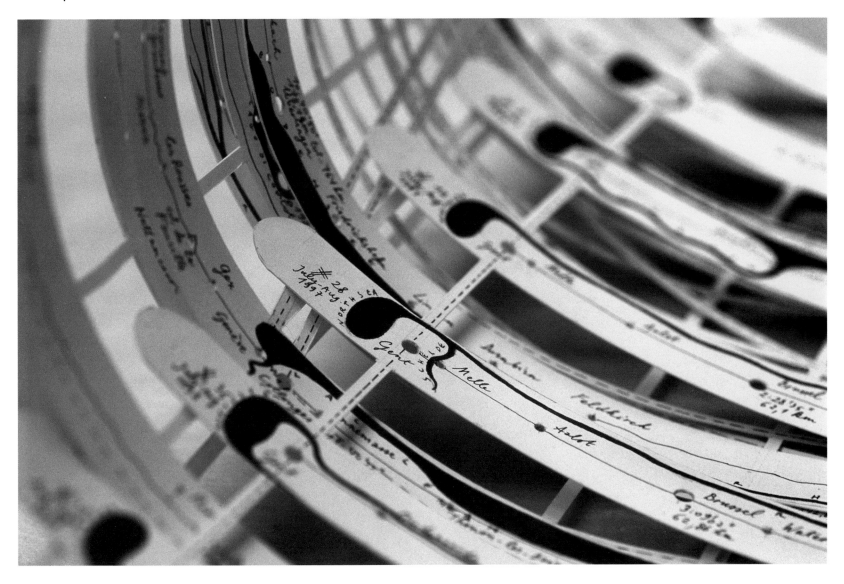

Atlas of Movements, Studies of Continental
Europe (bicycle), a selection: movements #6
(Gent-Faro), #7 (Gent-Genève-Zürich-Gent),
#8 (Gent-Den Haag-Gent), #12 (Gent-Venetia-
Gent), #28 (Gent-tour du Mt Blanc-Gent), #35
(Gent-Etna(-Gent)), #37 (Gent-Pointe de corsen-
Grenoble-Genève-Gent): Reworked version
Blue and black ink on paper cut-out
(2003)

Atlas of Movements, Studies of Continental
Europe (bicycle), a selection: movements #6
(Gent-Faro), #7 (Gent-Genève-Zürich-Gent),
#8 (Gent-Den Haag-Gent), #12 (Gent-Venetia-
Gent), #28 (Gent-tour du Mt Blanc-Gent), #35
(Gent-Etna(-Gent)), #37 (Gent-Pointe de corsen-
Grenoble-Genève-Gent): Reworked version
Blue ink on paper
(2000–3)

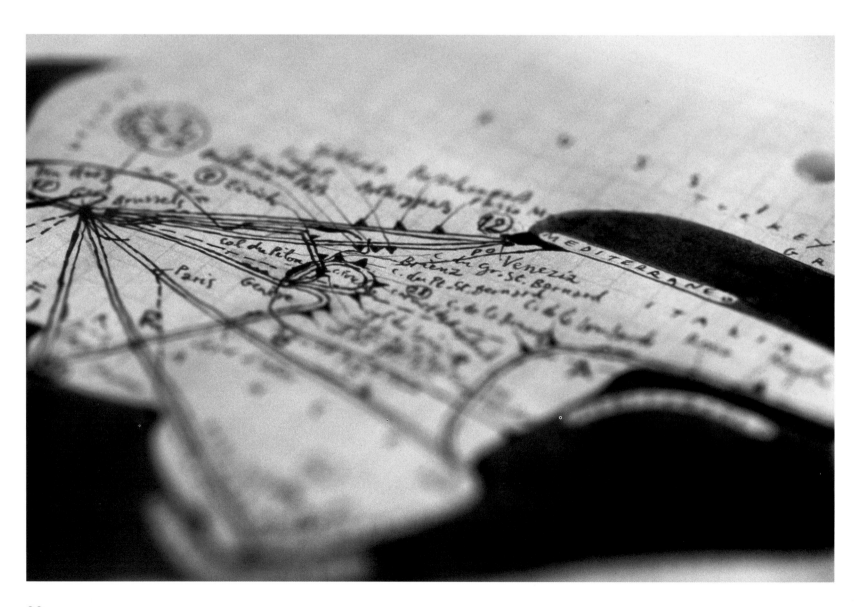

christoph fink

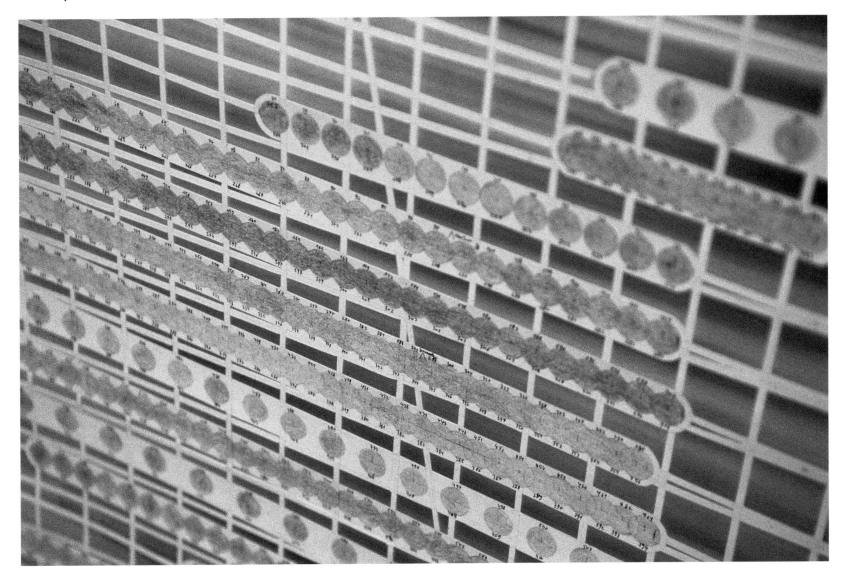

Atlas of Movements, Movement 35 (Gent-Etna
(-Gent)): detail: Reworked version
Pencil and ink on paper cut-out detail
(1998–2003)

31

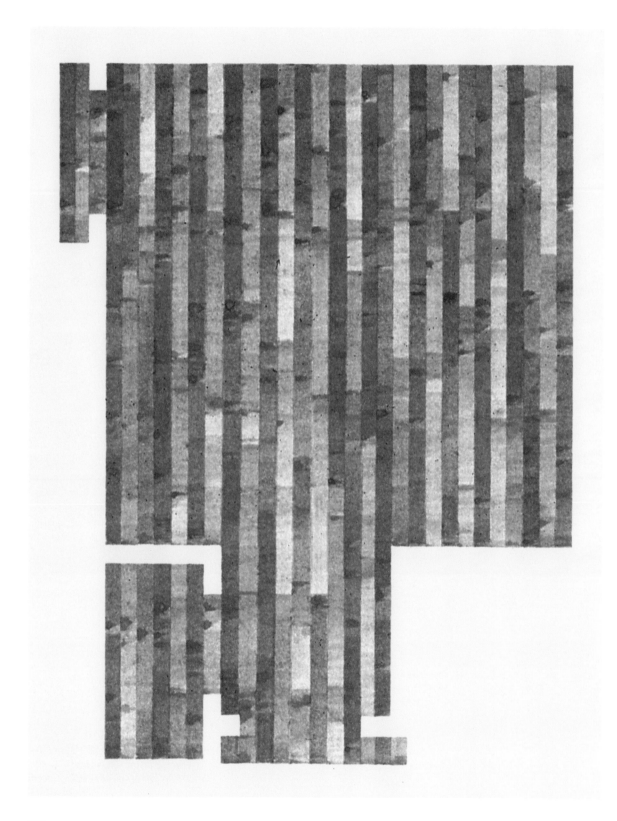

[Shadow drawing for] Living Room
SouthEast – two
Gouache on paper
(2002)

maryclare foa

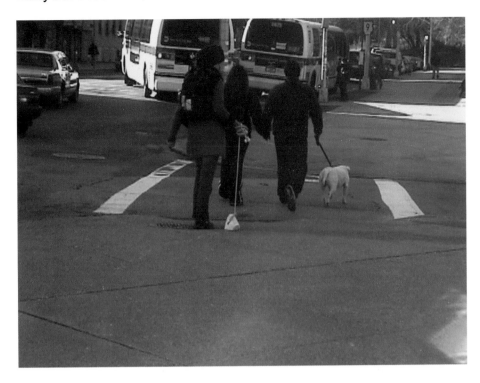

Manhattan Trace, 31st December 2003, 16 miles
approx. (18.56 kilometres)
Raw Hertfordshire chalk on New York pavement
2003

maryclare foa

maryclare foa

maryclare foa

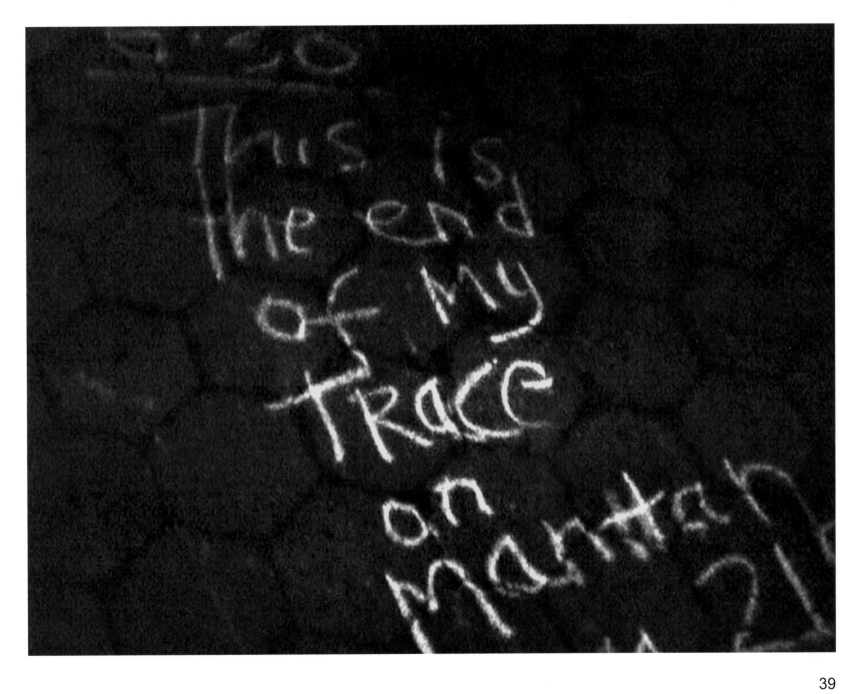

Woman with direct attitude & no personality that likes to go shopping with her mother *Pencil on paper* (2004)

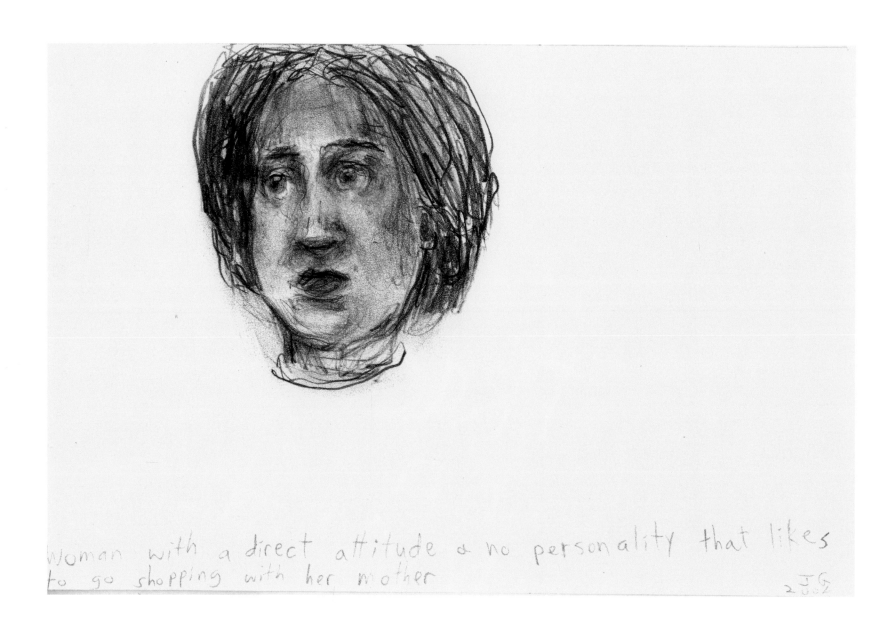

jeff gabel

British father at 3-yr-old's birthday party where
everyone is drinking socially
Pencil on paper
2003

British father at a 3-yr-old's birthday party where everyone is drinking socially

3:21 *Pencil on Fabriano* (2000)

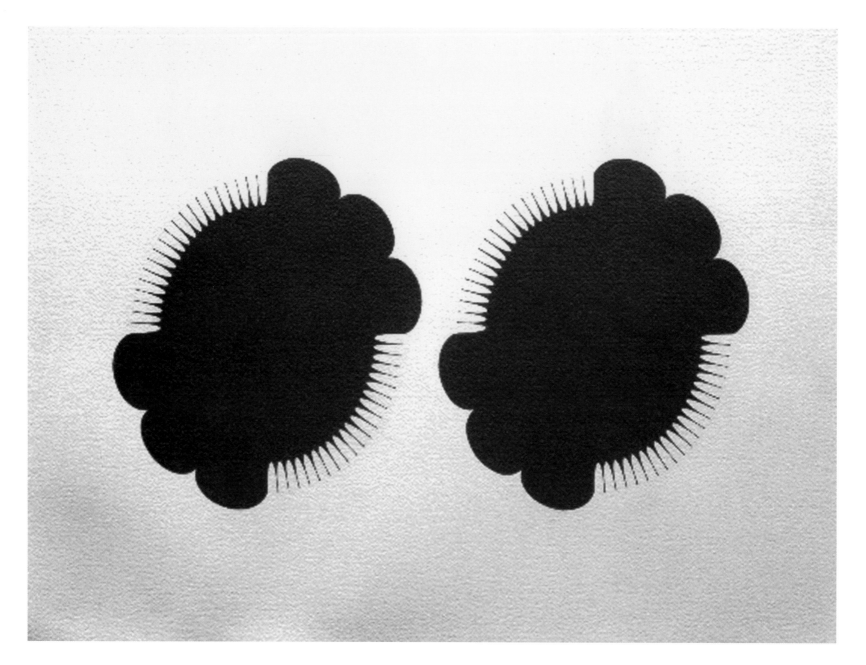

susan hauptman

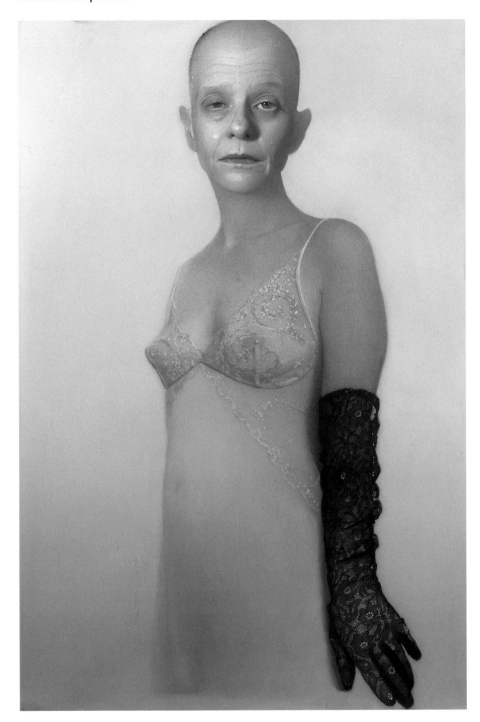

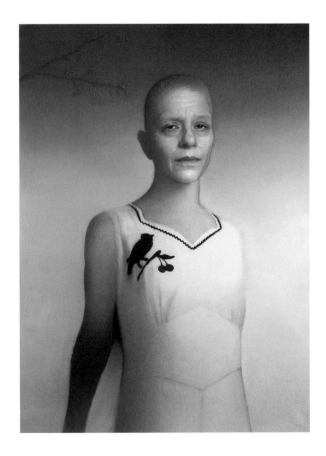

Self-Portrait (with Branch)
Charcoal on paper
2004

Self-Portrait (La Perla #2) *Charcoal on paper* (2005)

43

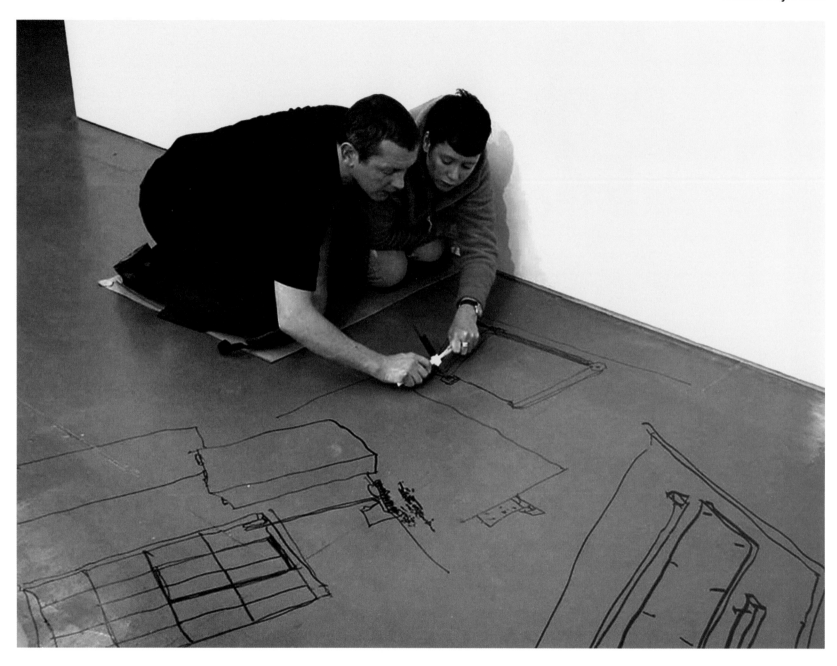

Work - Shy: collaborative drawing
Marker pen with stick attached, floor and walls of
project space
(2001)

jon houlding

The Beginning (Plenum I)
*Pen and ink on paper, mounted on
two-part wooden structure, three felt
sandbags, cord*
(2005)

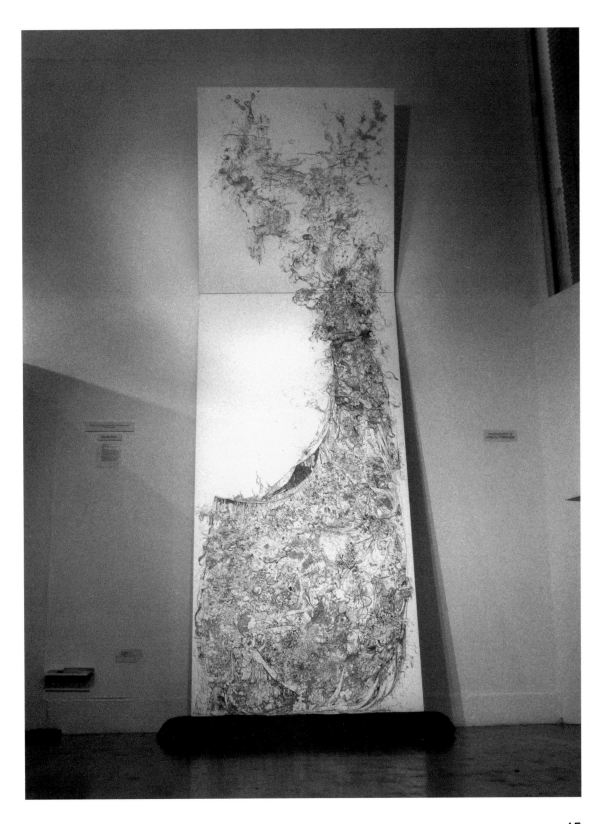

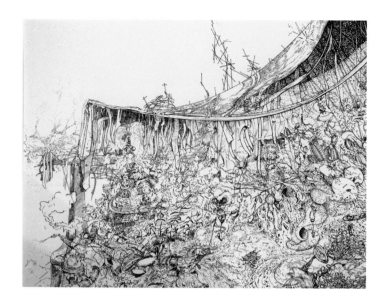

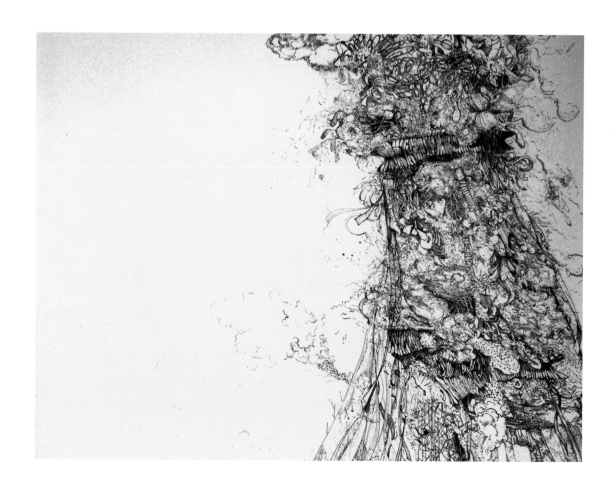

jon houlding

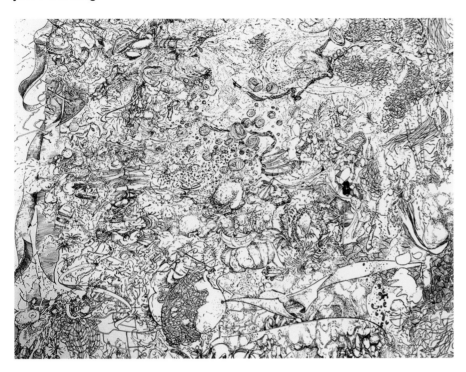

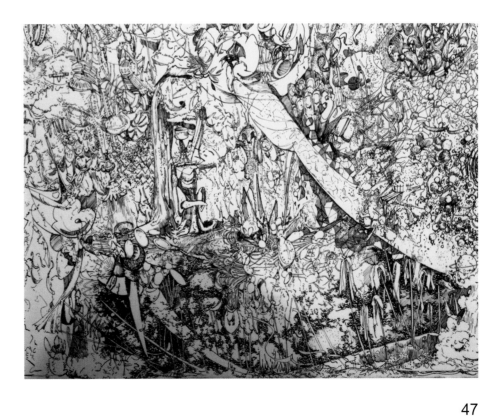

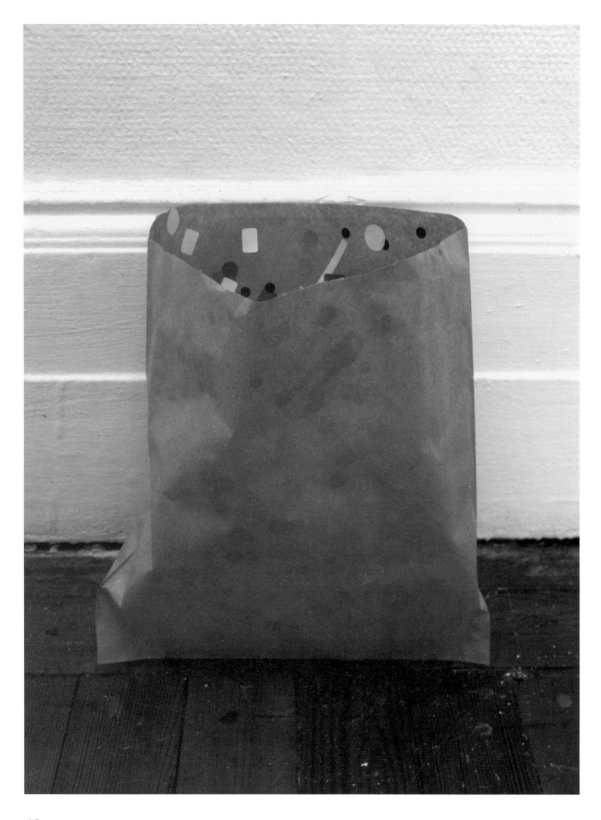

A paper bag with some stickers stuck inside it
Brown paper bag, adhesive stickers (2006)

benoît jacques

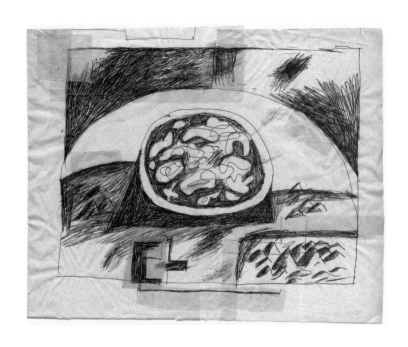

L' Astre Blue
Ballpen and collages on pattern-making paper
(2005)

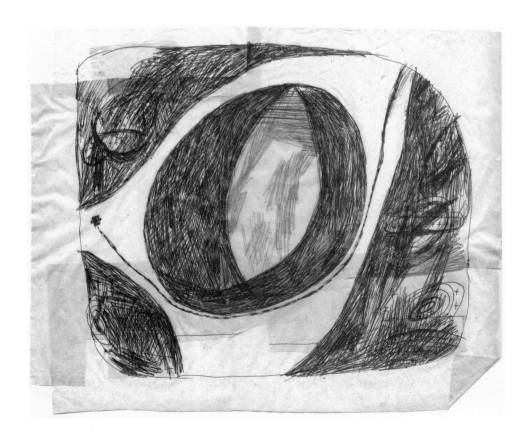

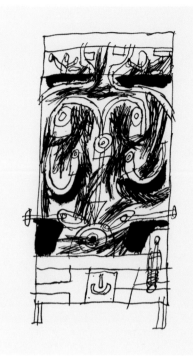

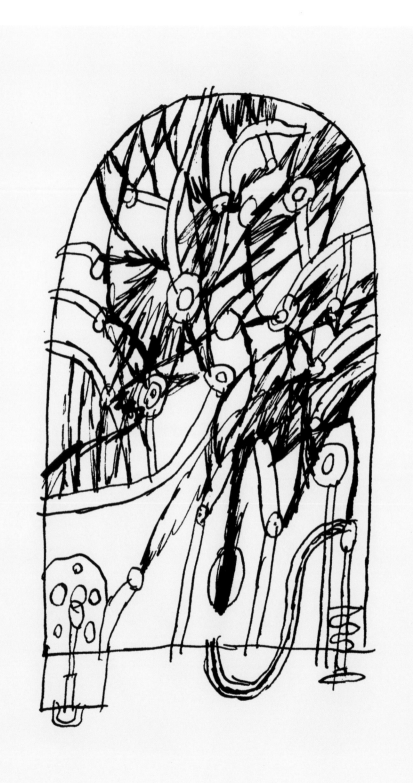

Je Flipper
Pen and ink on paper
(2005)

benoît jacques

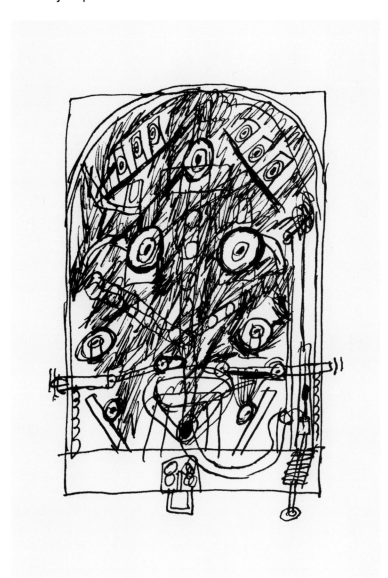

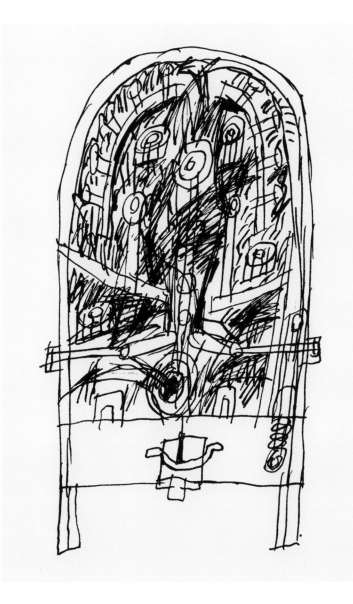

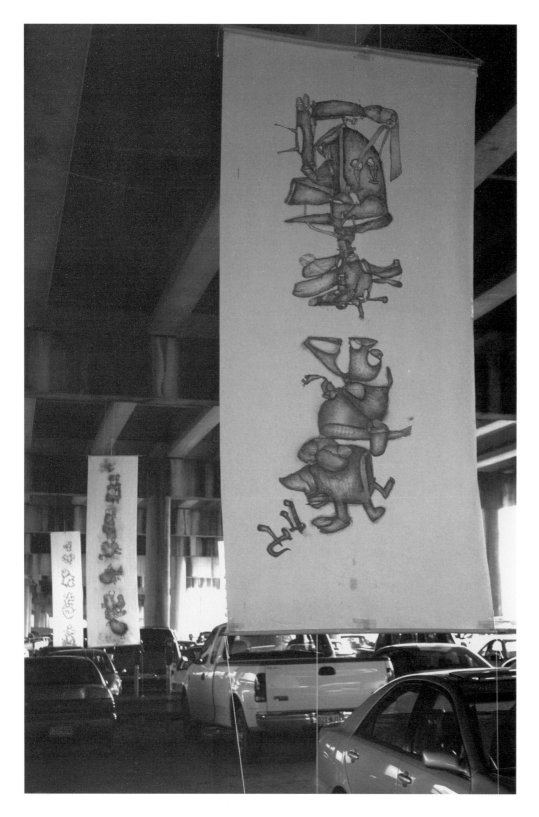

King Pain, under 59 & 110 Freeway by Diverse
Works, Houston
Marker, oil, coloured pencil
(2005)

marvin jordana

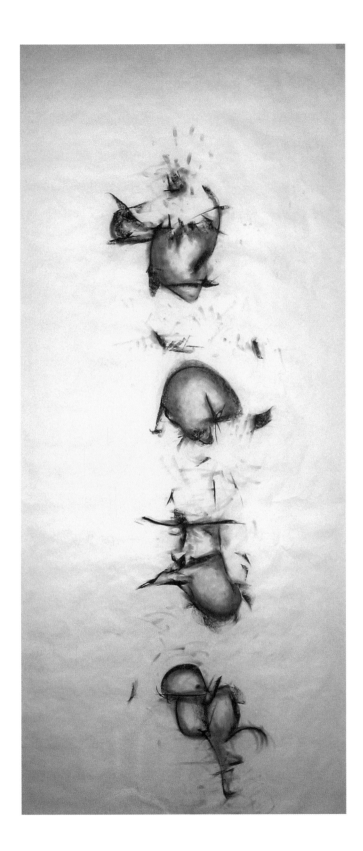

Cali-Graphy, The Box, Los Angeles
Charcoal
(2005)

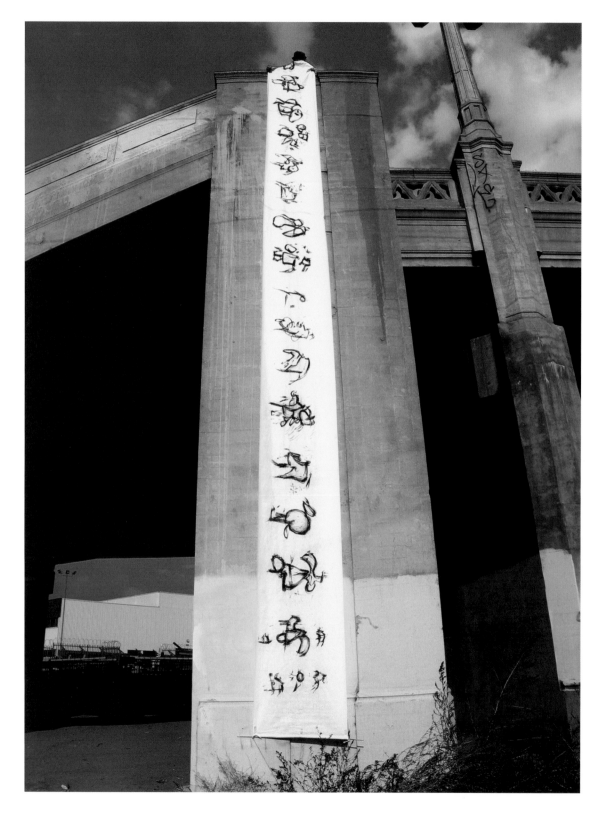

Scroll, 1st Street Bridge, East Los Angeles
Charcoal
(2004)

naomi kashiwagi

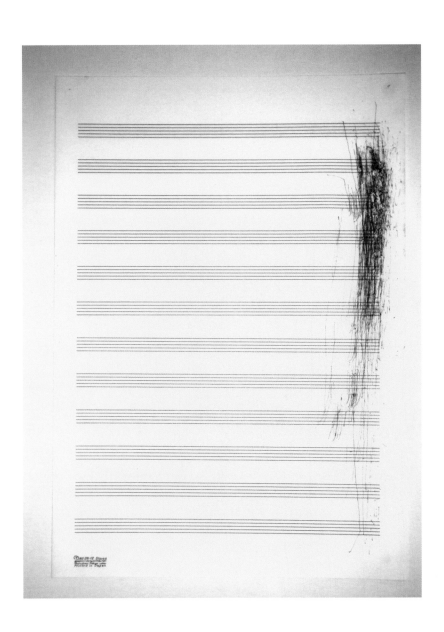

Of course it would have worn out
sooner or later
Pen, manuscript paper, piano
(2005)

Hemmed in Two – Luckman Version
Cardboard, acrylic, marker pen, wood, mixed media
(2004)

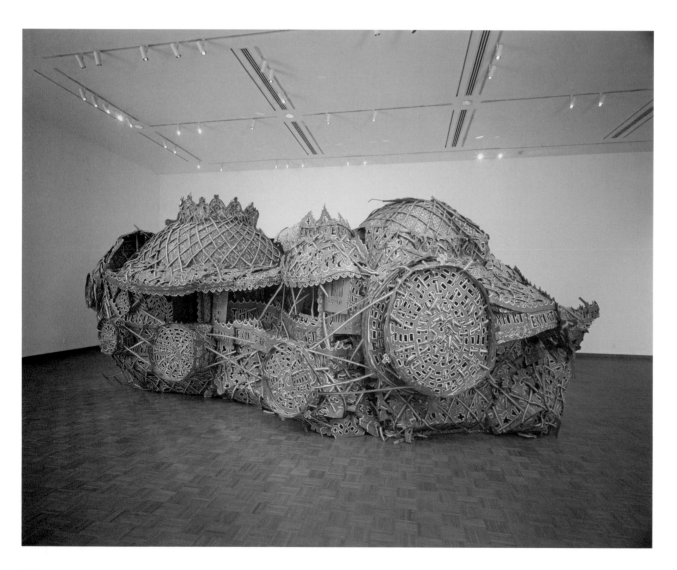

james madden

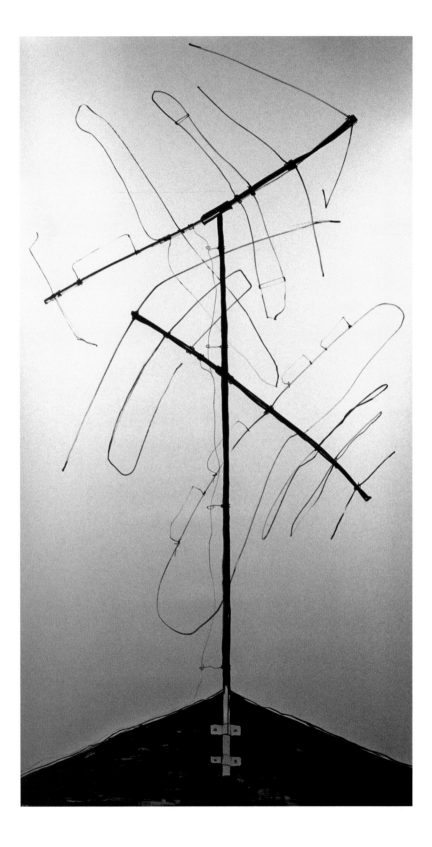

Sentinel
India ink on paper
(2002)

Manual to Settle Sediments
(a drawing biography)
H9 lead on paper
(2003)

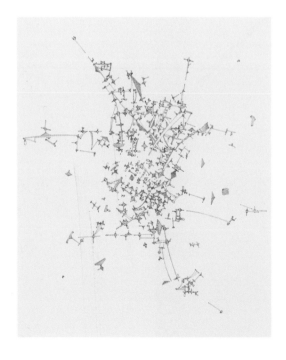

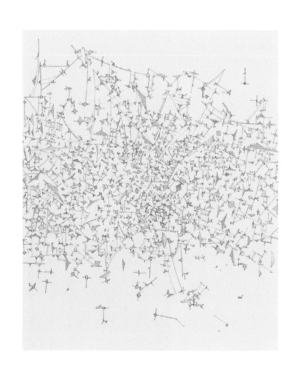

marco maggi

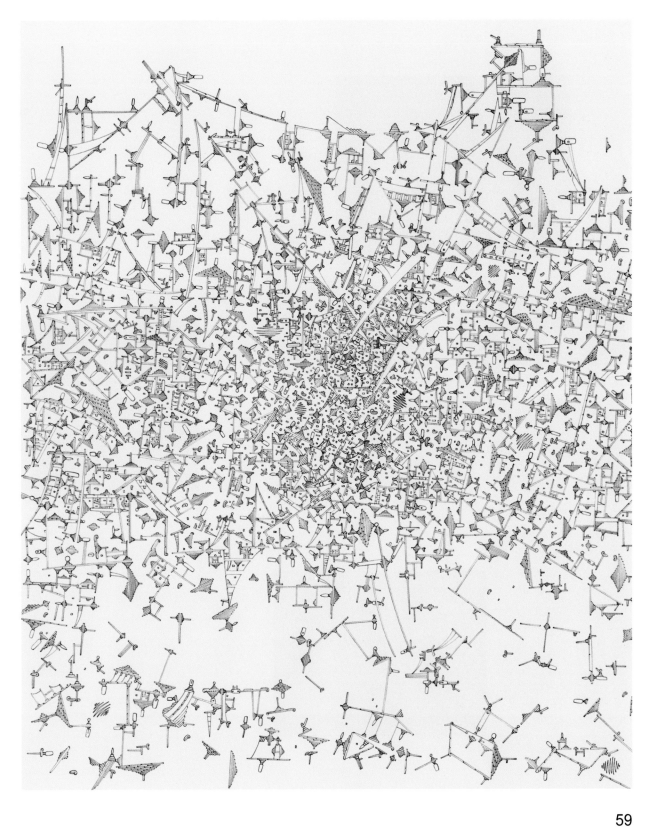

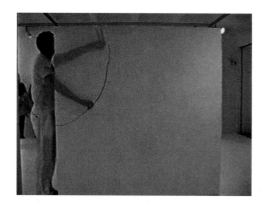

Untitled: Die
MDF, pastel, graphite
(2002)

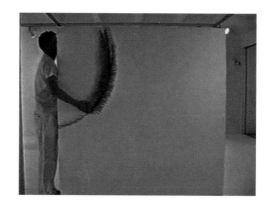

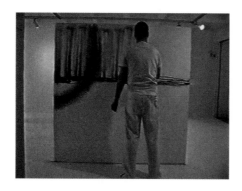

jordan mckenzie

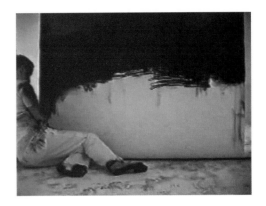

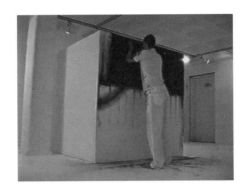

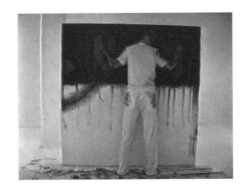

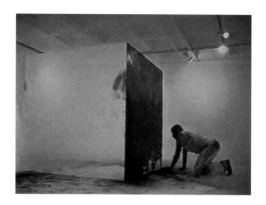

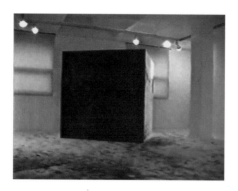

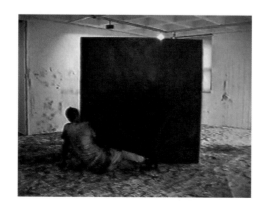

jordan mckenzie

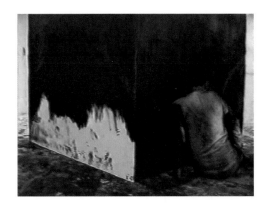

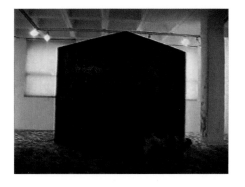

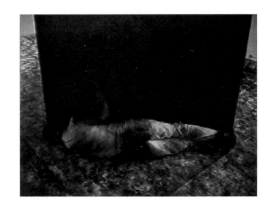

Brewed Ink *Tar* (2002)

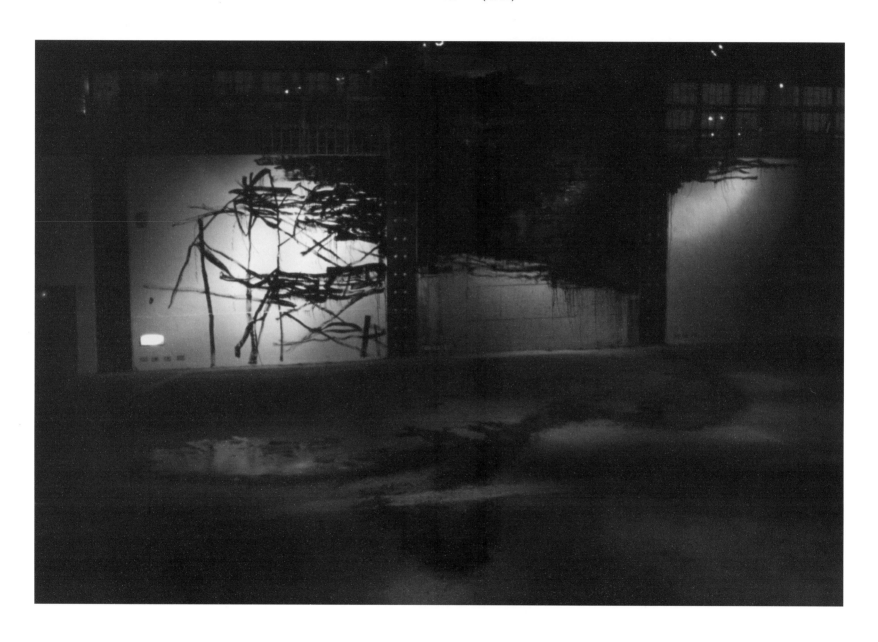

ming-hui chen

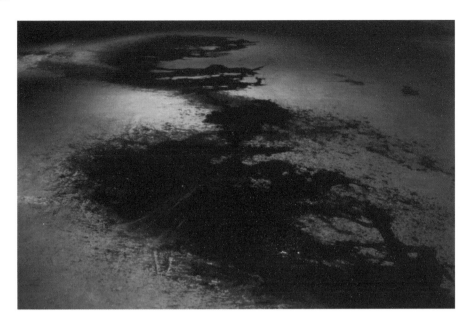

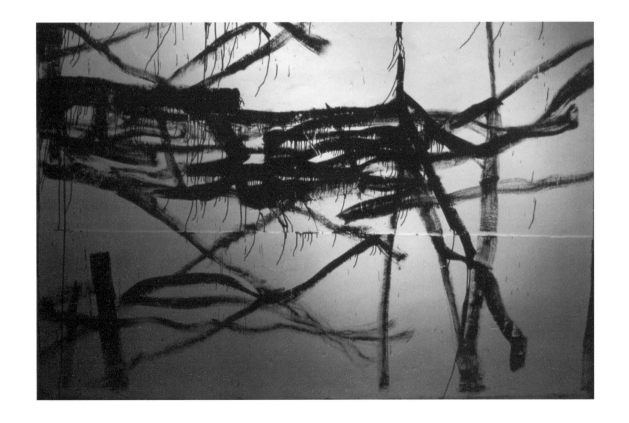

Sea V The Carnival Between
Pencil on paper
(2005)

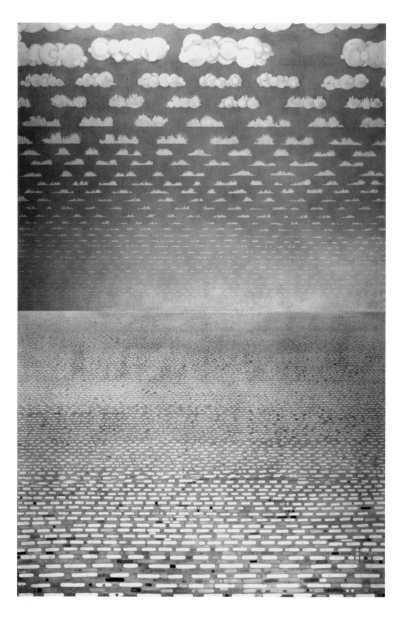

paul noble

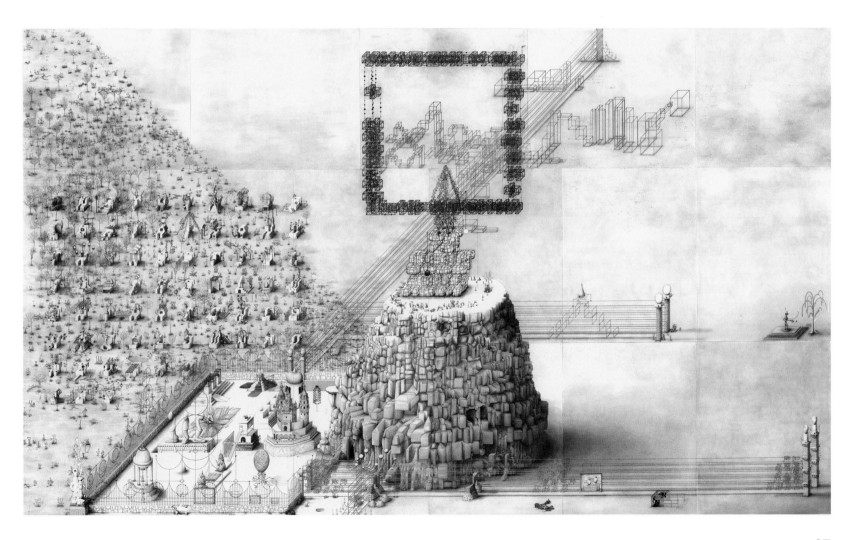

Landscaping
Super 8 mm film stills
(2005)

john o'connell

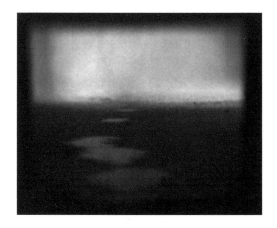

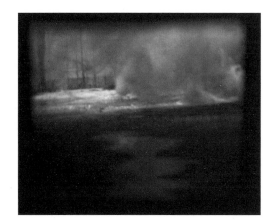

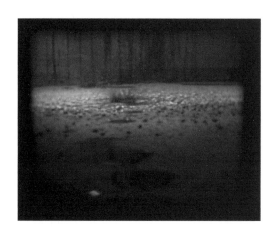

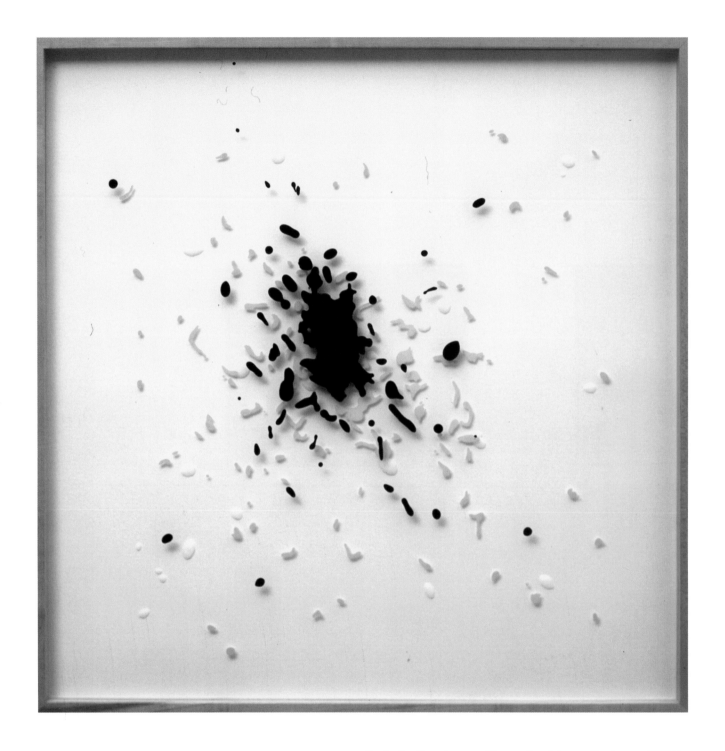

Explosion Drawing *Charcoal, sulphur, saltpetre* (2001)

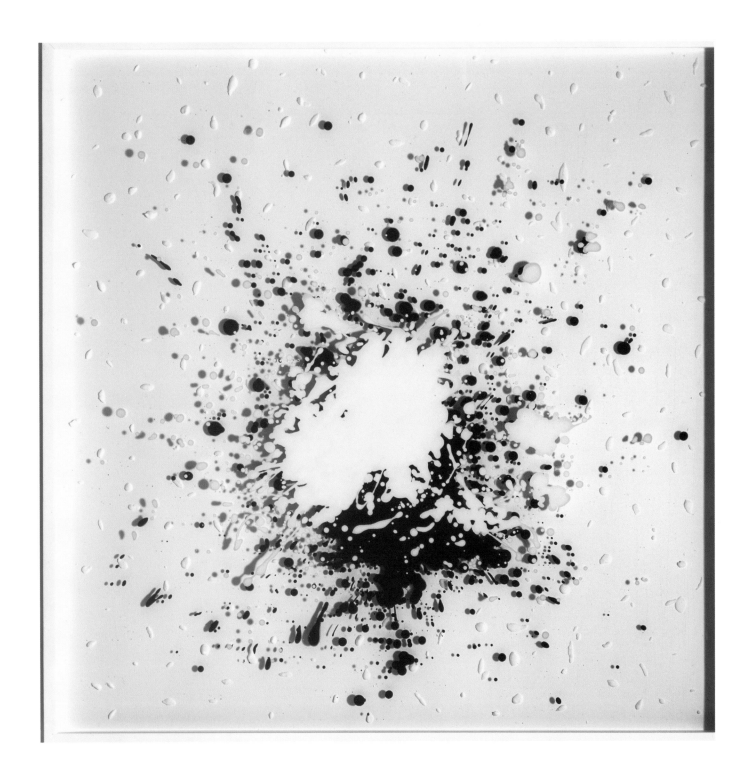

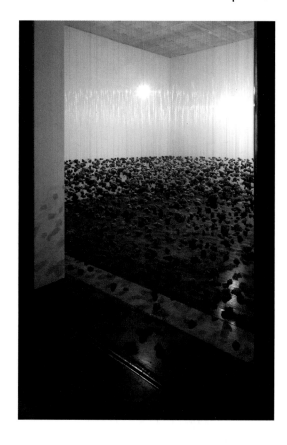

Subconscious of a Monument
*Soil excavated from beneath the Leaning
Tower of Pisa, wire*
(2005)

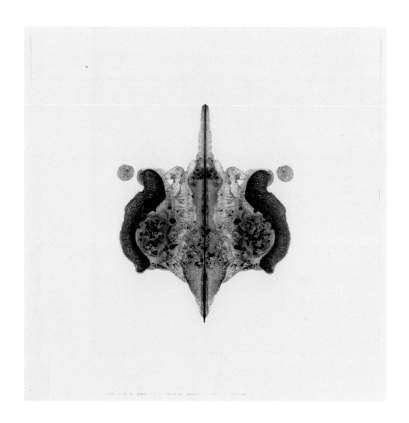

Pornographic Drawing
*Ink made from dissolving video tape
(confiscated by HM Customs & Ex-
cise) in solvent*
(2005)

charles poulsen

27th January 2006, two
Wax stick and black gouache, on Fabriano
(2006)

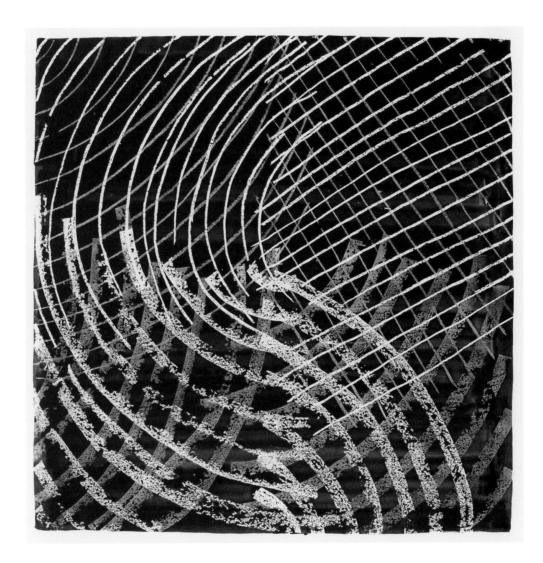

Installation view of the Elector Series, at Portikus, Frankfurt-am-Main, Germany *Mixed media* (2005)

matthew ritchie

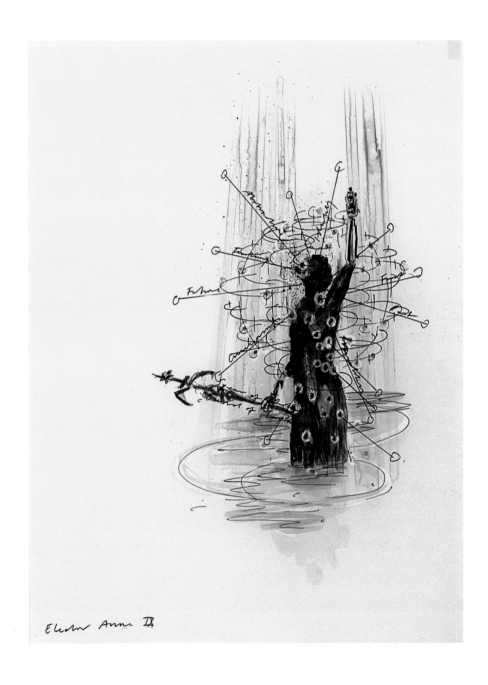

Elector Anne IX
Ink on Denril
(2005)

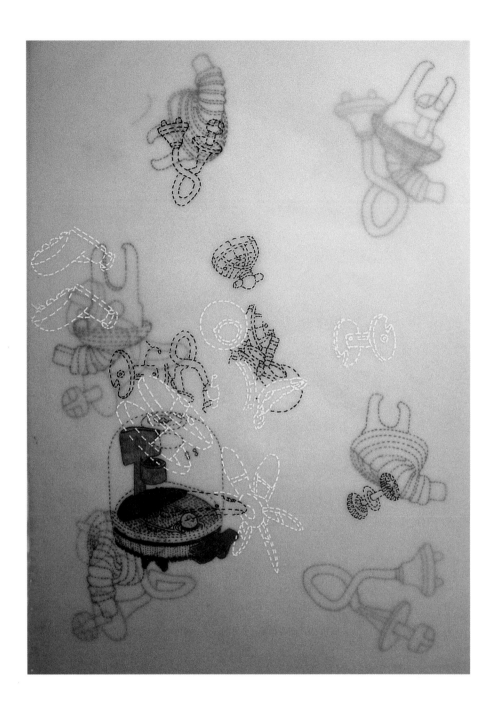

'Kinder' Drawing series
Tracing paper, drafting film, gel pen, pen and ink
(2005)

annette robinson

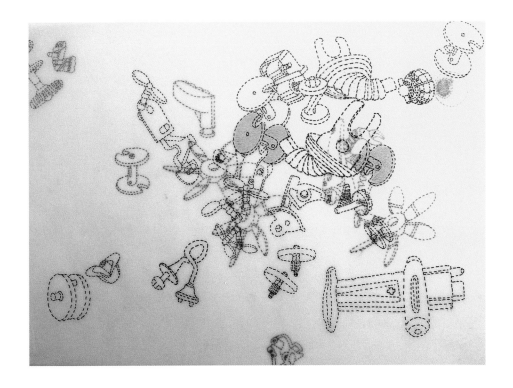

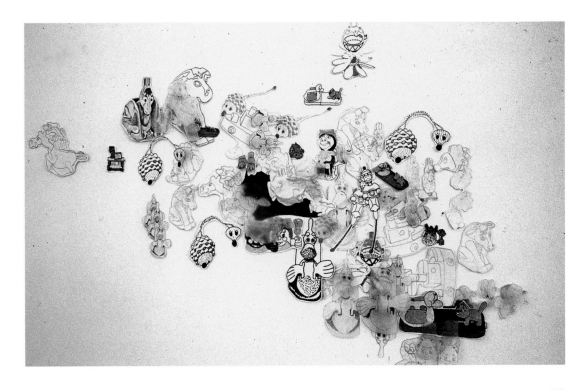

FUENFZEHNTERJUNIZWEITAUSENDUNDDREI *Ink on paper, wooden frame* (2003)

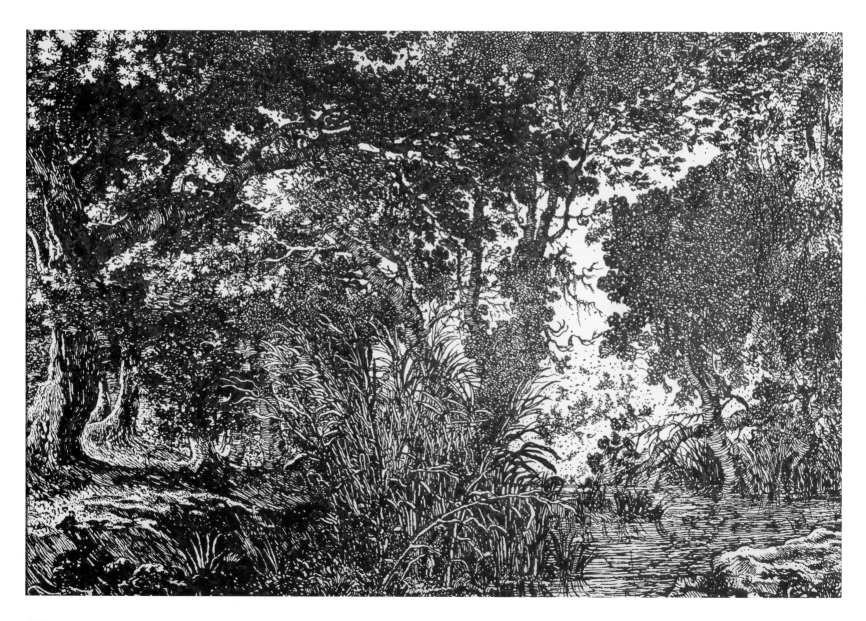

ugo rondinone

NEUNUNDZWANZIGSTERJULIZWEITAUSENDUNDZWEI *Ink on paper, wooden frame* (2002)

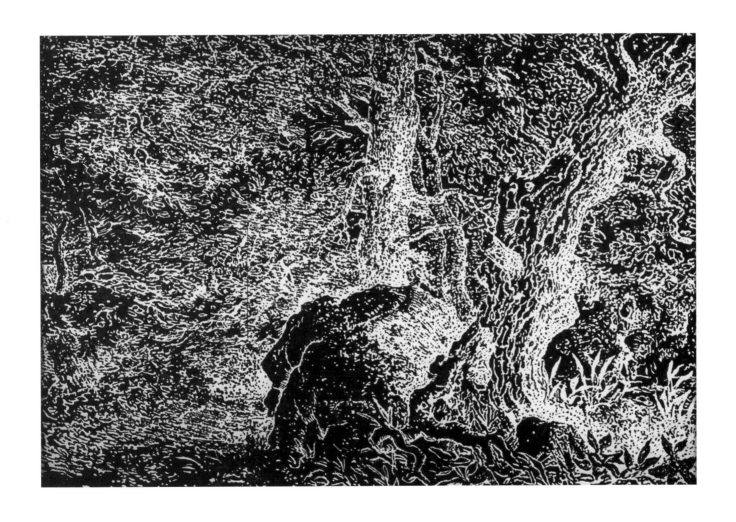

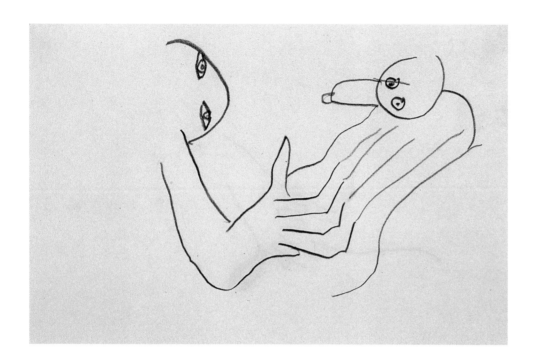

Vertige d'Amour
Graphite on paper
(2005)

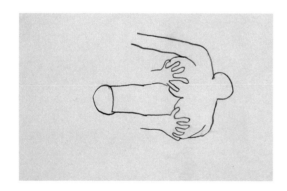

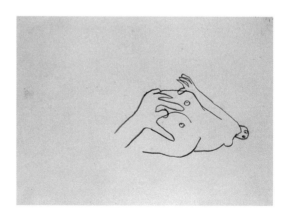

anne-marie schneider

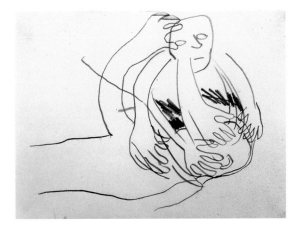

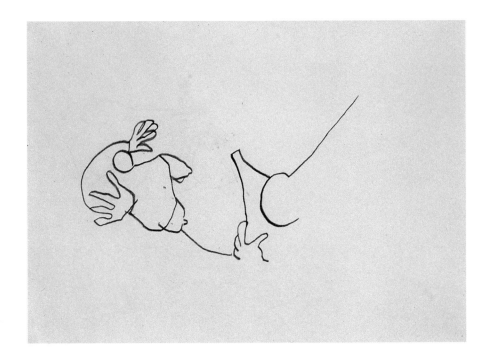

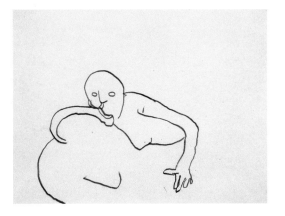

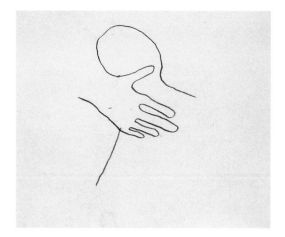

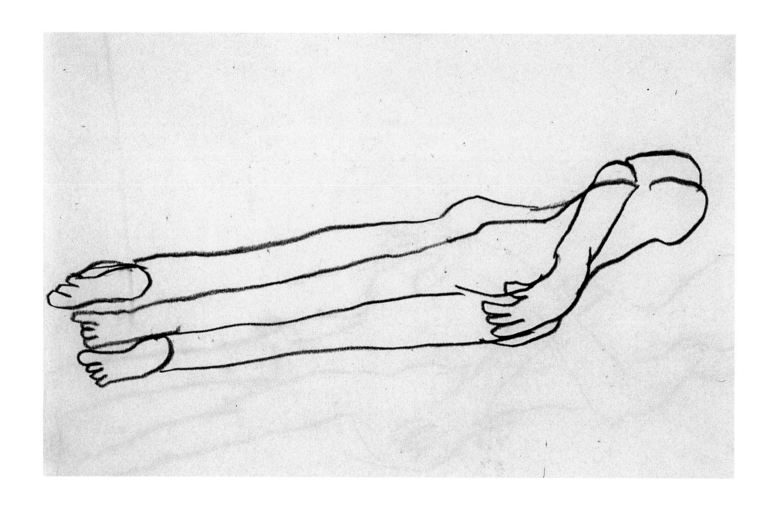

anne-marie schneider

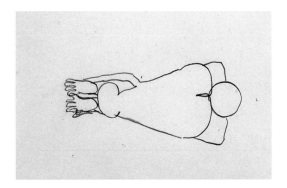

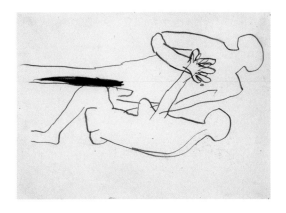

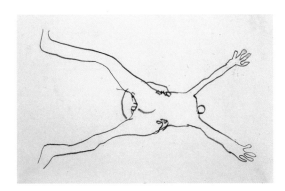

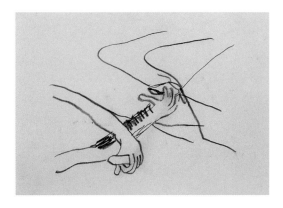

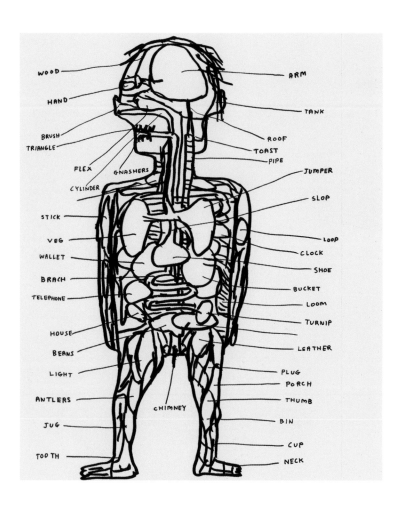

Untitled *Ink on paper* (2005)

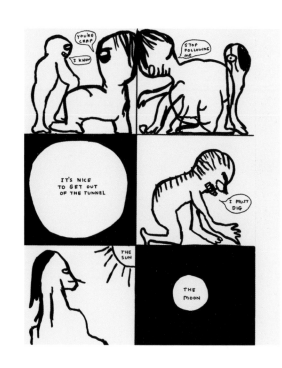

david shrigley

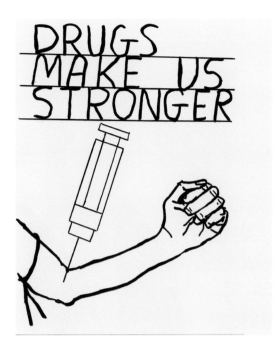

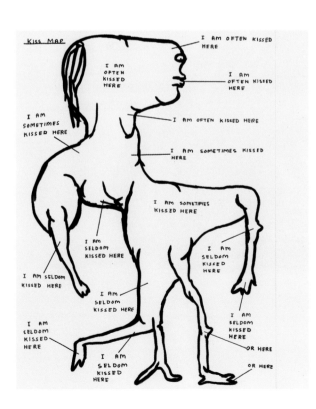

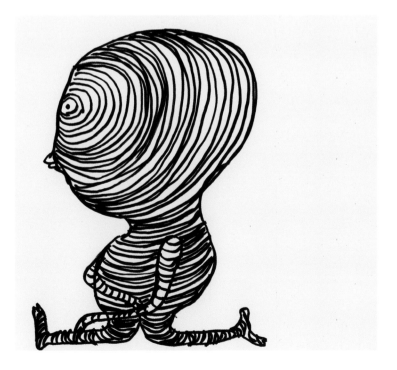

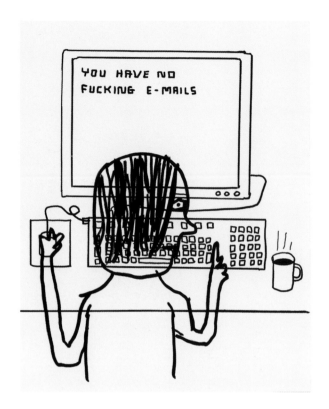

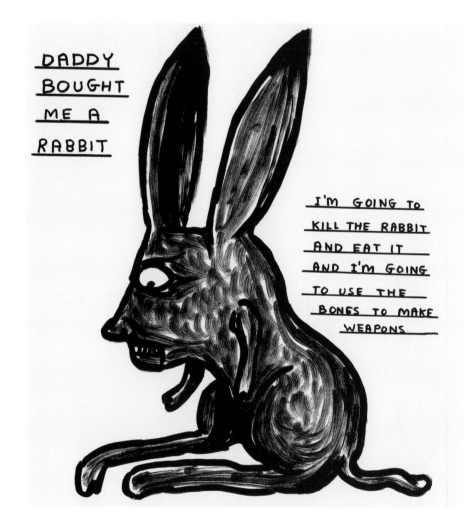

barthélémy toguo

The Lovers Bed II
Watercolour on paper
(2004)

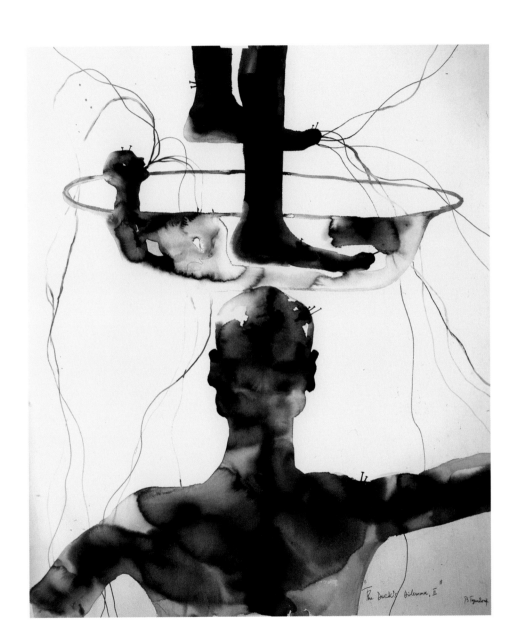

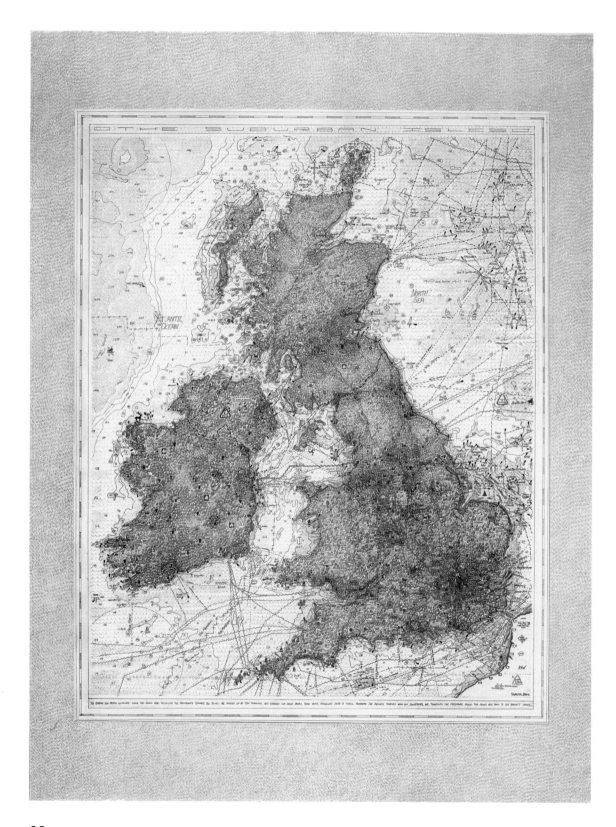

The Suburban Isles (Similands)
Pencil on paper collage
(2004–5)

stephen walter

Detail 2 Throw Away After Use, A London Town *Pencil on paper* (2002–4)

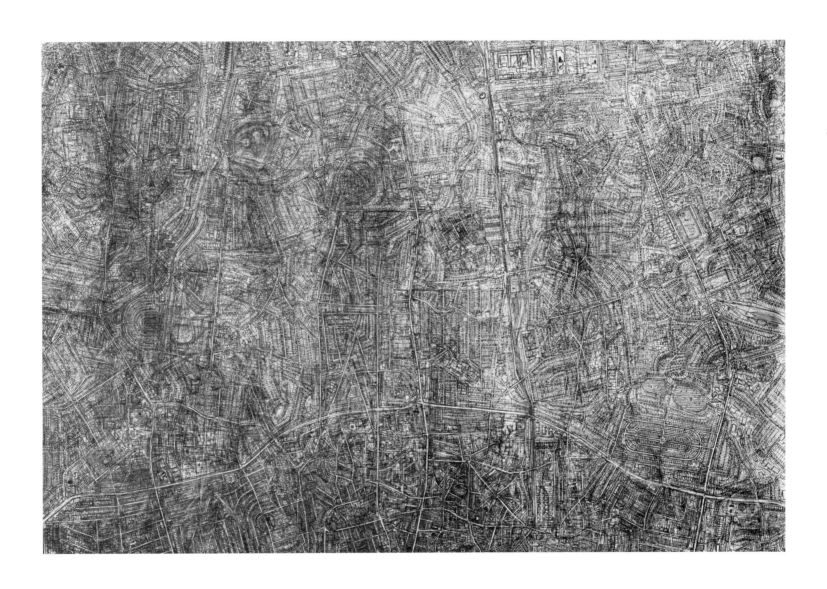

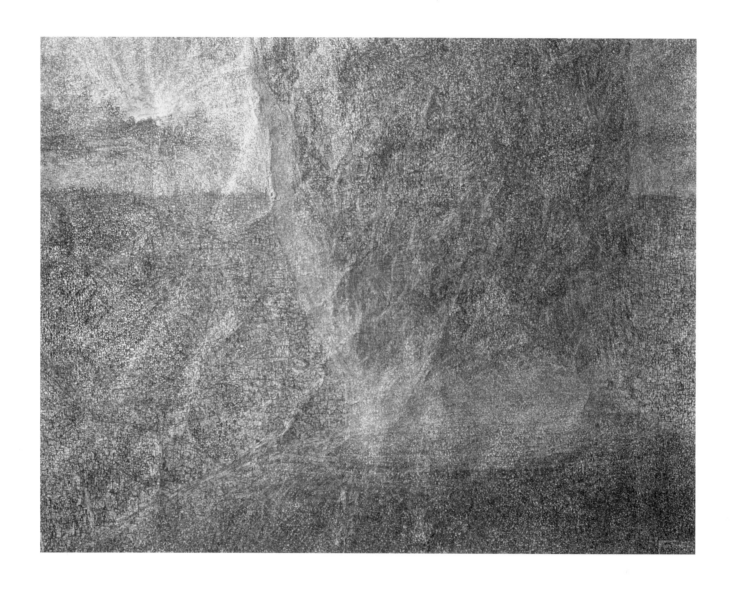

Detail 3 Once Upon A Time – There was a Land
Covered in Forest, Then There was a City, Then
a Suburbanite Thinking About Trees
Pencil on paper
(2002–4)

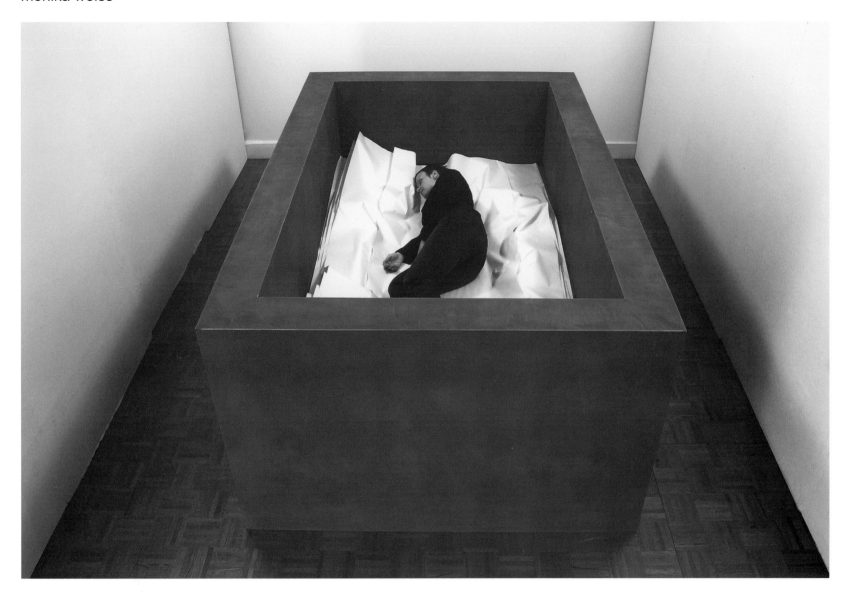

Lethe Room: View of the installation at the Lehman College Art Gallery
Plaster, metal, wood, motor, crayons, pigment, paper, the artist
(2004)

The Garden *Pencil on paper in perspex box* (2005)

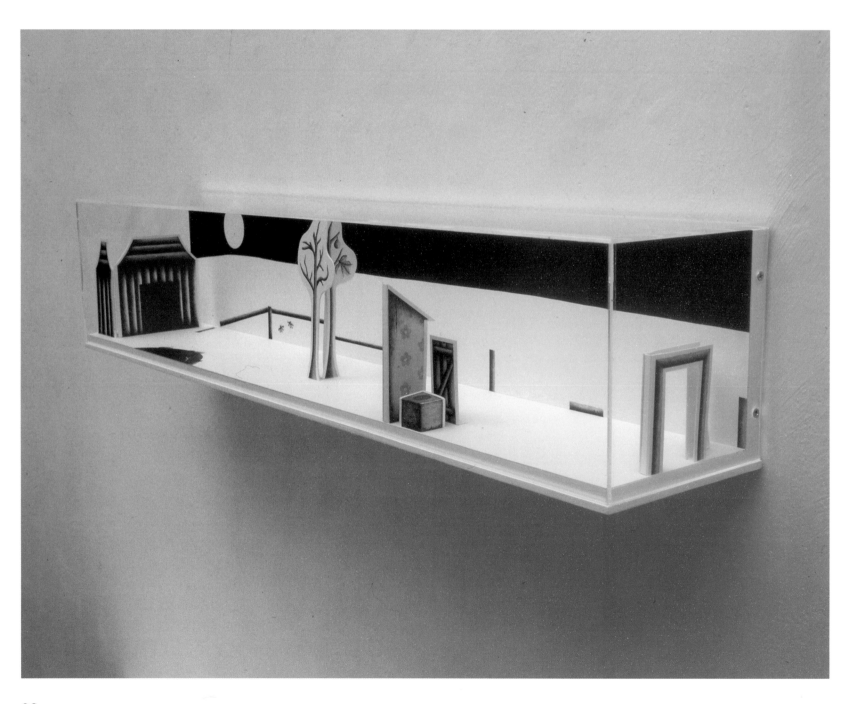

sarah woodfine

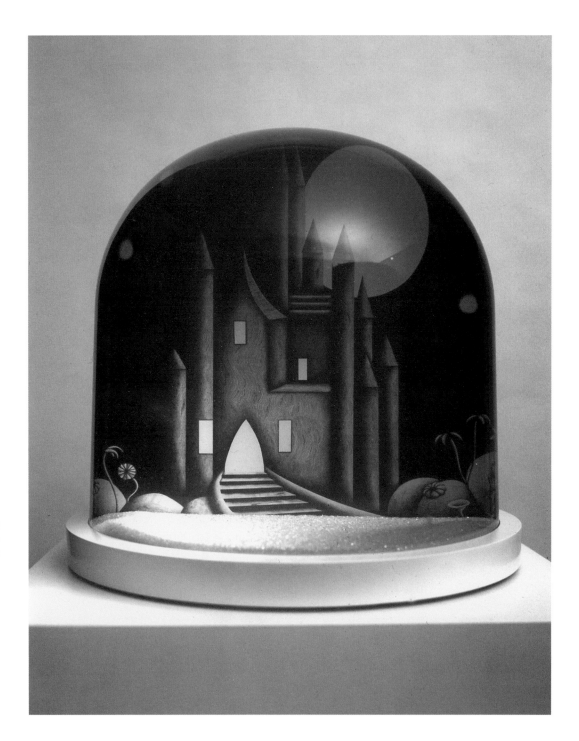

Untitled (Castle)
Pencil on paper in snow dome
(2005)

spanisch/American table of conspiracy

+ italy

Spanish/American table of conspiracy *Pen and paper* (2003)

edwin wurm

The Idiot
Pencil and paper
(2003)

artwork details

page 2
Anna Barriball
Black Wardrobe
Tape on wardrobe
2003
177.8 x 70 x 40 cm
Installation View Frith Street Gallery, London 2003
Saatchi Collection
Courtesy the artist and Frith Street Gallery, London
Photographs Stephen White

page 3
Anna Barriball
One Square Foot VI
Pencil on paper
2002
30 x 30 cm
Courtesy the artist and Frith Street Gallery, London
Photographs Stephen White

page 4
Nayland Blake
Untitled
Charcoal on paper
2000
48¾ x 38½ inches
© Nayland Blake
Courtesy Matthew Marks Gallery, New York

page 5
Nayland Blake
Untitled
Graphite on paper
2005
12 x 9 inches
© Nayland Blake
Courtesy Matthew Marks Gallery, New York

page 6
Astrid Bowlby
Chrysanthemum 2
Cut paper
2006
180 x 360 x 72 inches overall

Astrid Bowlby
On Some Far: Detail
Ink on cut paper
2003
72 x 330 x 312 inches overall

page 7
Julie Brixey-Williams
*Locationotation, Deborah 9 Deborah Kay Ward, in Front
 Room, Islington, London N1, 11.30 am on Sat 9th June
 2001*
Graphite powder on watercolour paper
2001
21 x 29.6 cm

page 8
Julie Brixey-Williams
*Locationotation, Abigail 10 Abigail Salisbury, in Kensal
 Green Cemetery, 11.30 am on Sat 9th June 2001*
Graphite powder on watercolour paper
2001
21 x 29.6 cm

Julie Brixey-Williams
*Locationotation, Niki 25 Niki McCretton, on the Manager's
 Desk at the Tacchi-Morris Arts Centre, Taunton, Devon,
 11.30 am on Sat 9th June 2001*
Graphite powder on watercolour paper
2001
21 x 29.6 cm

page 9
Julie Brixey-Williams
*Locationotation, Mel 36 Mel Shearsmith, on Grass, Inside
 a Bamboo Pyramid next to Clifton Observatory, Bristol,
 11.30 am on Sat 9th June 2001*
Graphite powder on watercolour paper
2001
21 x 29.6 cm

Julie Brixey-Williams
*Locationotation, Susan 48 Susan Bowman, on a Tiled Floor,
 in the Kitchen, Ealing W13, 11.30 am on Sat 9th June
 2001*

Graphite powder on watercolour paper
2001
21 x 29.6 cm

page 10
Julie Brixey-Williams
*Locationotation, Brenda 50 Brenda Hawkes, on a Tiled
 Floor, in the Kitchen, Ealing W13, 11.30 am on Sat 9th
 June 2001*
Graphite powder on watercolour paper
2001
21 x 29.6 cm

page 11
Julie Brixey-Williams
*Locationotation, Joe 55 Joe Ballantyne, on the Pavement,
 by the Bus Stop, Newham Grange Road, Cambridge,
 11.30 am on Sat 9th June 2001*
Graphite powder on watercolour paper
2001
21 x 29.6 cm

Julie Brixey-Williams
*Locationotation, Beccy 60 Beccy Birchill, on a Lino Floor,
 in the Warm-Up Studio, Harbour House, Kingsbridge,
 Devon, 11.30 am on Sat 9th June 2001*
Graphite powder on watercolour paper
2001
21 x 29.6 cm

pages 12–15
Javier Cambre
Another Night in Rented Rooms
Graphite on paper
2003
30.5 x 30.5 cm
Collection of Jorge Bared

page 16
Louise Clarke
Feather Light
Dip pen and ink
2005
4 x 3 inches

page 17
Cullinan + Richards artlab
*Savage School Text Type 11, Commemorative Schematic
 Drawing C+J Racing Tapestry for Working Women's
 Club Bar for Shock Workers Kent Whitstable Lydden
 Race Track*
Watercolour, felt pen, pencil on watercolour paper
2006
21 x 29.7 cm

page 18
Angela Eames
Making It Up Ink
Inkjet print on canvas on stretcher
2004
154 x 154 cm

page 19
Angela Eames
Making It Up Graphite
Inkjet print on canvas on stretcher
2004
154 x154 cm

page 20
Angela Eames
Making It Up Biro
Inkjet print on canvas on stretcher
2004
154 x154 cm

page 21
Angela Eames
Making It Up Charcoal
Inkjet print on canvas on stretcher
2004
154 x154 cm

page 22
Jacob El-Hanani
Gauze
Ink on paper
2001

page 23
Tracey Emin
Sexy Dolly
Monoprint on paper
2005
66 x 88.7 cm including frame
© the artist
Courtesy Jay Jopling/ White Cube, London
Photograph Stephen White

page 24
Simon Evans
Failing at Living Alone
Mixed media on paper
2005
Courtesy of Jack Hanley Gallery, San Francisco

page 25
Simon Evans
Ideas for New Continents
Mixed media on paper
2004
41.3 x 35.6 cm
Courtesy of Jack Hanley Gallery, San Francisco

page 26
Brian Fay
Woman Meditating after Corot
Digital drawing on paper
2005
Dimensions variable

page 27
Brian Fay
Vermeer x 3
Digital drawing on paper
2005
Dimensions variable

page 28
Christoph Fink
*Atlas of Movements, Studies of Continental Europe
 (bicycle), a selection: movements #6 (Gent-Faro), #7
 (Gent-Genève-Zürich-Gent), #8 (Gent-Den Haag-Gent),
 #12 (Gent-Venetia-Gent), #28 (Gent-tour du Mt Blanc-
 Gent), #35 (Gent-Etna(-Gent)), #37 (Gent-Pointe de
 corsen-Grenoble-Genève-Gent)*
Blue ink on paper
2000–3
357 x 41.5 cm
© Christoph Fink

page 29
Christoph Fink
*Atlas of Movements, Studies of Continental Europe
 (bicycle), a selection: movements #6 (Gent-Faro), #7
 (Gent-Genève-Zürich-Gent), #8 (Gent-Den Haag-Gent),
 #12 (Gent-Venetia-Gent), #28 (Gent-tour du Mt Blanc-
 Gent), #35 (Gent-Etna(-Gent)), #37 (Gent-Pointe de
 corsen-Grenoble-Genève-Gent): Reworked version*
Blue and black ink on paper cut-out
2003
21 x 16.5 cm
© Christoph Fink

page 30
Christoph Fink
*Atlas of Movements, Studies of Continental Europe
 (bicycle), a selection: movements #6 (Gent-Faro), #7
 (Gent-Genève-Zürich-Gent), #8 (Gent-Den Haag-Gent),
 #12 (Gent-Venetia-Gent), #28 (Gent-tour du Mt Blanc-
 Gent), #35 (Gent-Etna(-Gent)), #37 (Gent-Pointe de
 corsen-Grenoble-Genève-Gent): Reworked version*
Blue ink on paper
2000–3
357 x 41.5 cm
© Christoph Fink

page 31
Christoph Fink
*Atlas of Movements, Movement 35 (Gent-Etna (-Gent)):
 detail: Reworked version*
Pencil and ink on paper cut-out detail
1998–2003
46 x 41¾ inches
© Christoph Fink

page 32
Julia Fish
[Shadow drawing for] Living Room SouthEast – Two
Gouache on paper
2002
25 x 22.5 inches

pages 33–9
Maryclare Foa
*Manhattan Trace, 31st December 2003, 16 miles approx.
 (18.56 kilometres)*
Raw Hertfordshire chalk on New York pavement
2003

page 40
Jeff Gabel
*Woman with Direct Attitude & no Personality that Likes to
 go Shopping with her Mother*
Pencil on paper
2004
10.8 x 17.2 cm

page 41
Jeff Gabel
*British Father at 3-yr-old's Birthday Party where Everyone
 is Drinking Socially*
Pencil on paper
2003
15.25 x 21.6 cm

artwork details

page 42
Jane Harris
3:21
Pencil on Fabriano
2000
Private collection

page 43
Susan Hauptman
Self-Portrait (La Perla #2)
Charcoal on paper
2005
54¼ x 40 inches
© Susan Hauptman
Courtesy of Forum Gallery, New York

Susan Hauptman
Self-Portrait (with Branch)
Charcoal on paper
2004
52 x 38 inches
© Susan Hauptman
Courtesy of Forum Gallery, New York

page 44
Hewitt & Jordan
Work – Shy: Collaborative Drawing
Marker pen with stick attached, floor and walls of
 project space
2001

pages 45–7
Jon Houlding
The Beginning (Plenum I)
Pen and ink on paper, mounted on two-part wooden
 structure, three felt sandbags, cord
2005
381 x 121 cm

page 48
Dean Hughes
A Paper Bag with Some Stickers Stuck Inside It
Brown paper bag, adhesive stickers
2006
35 x 30 cms

page 49
Benoît Jacques
L'Astre Blue
Ballpen and collages on pattern-making paper
2005
26 x 35 cm

pages 50–1
Benoît Jacques
Je Flipper
Pen and ink on paper
2005
15 x 22 cm

page 52
Marvin Jordana
King Pain Under 59 and 110 Freeway by Diverse Works,
 Houston
Marker, oil, coloured pencil
2005
122 x 366 cm

page 53
Marvin Jordana
Cali-Graphy, The Box, Los Angeles
Charcoal
2005
91 x 366 cm

page 54
Marvin Jordana
Scroll, 1st Street Bridge, East Los Angeles
Charcoal
2004
91 x 792 cm

page 55
Naomi Kashiwagi
Of Course it Would Have Worn Out Sooner or Later
Pen, manuscript paper, piano
2005
20 x 29 cm

page 56
Hew Locke
Hemmed in Two – Luckman Version
Carboard, acrylic, marker pen, wood, mixed media
2004
© Hew Locke and DACS
Photograph Joshua White

page 57
James Madden
Sentinel
India ink on paper
2002
7 x 4 feet

pages 58–9
Marco Maggi
Manual to Settle Sediments (A Drawing Biography)

H9 lead on paper
2003
30 x 21 cm

pages 60–3
Jordan McKenzie
Untitled: Die
MDF, pastel, graphite
2002
190 x 190 x 190 cm

pages 64–5
Ming-Hui Chen
Brewed Ink
Tar
2002
1250 x 1450 x 550 cm
Shown at the Pier-2 Art District, Taiwan

page 66
Paul Noble
Sea V The Carnival Between
Pencil on paper
2005
300 x 200 cm
Courtesy Maureen Paley, London

page 67
Paul Noble
Ye Olde Ruin
Pencil on paper
2003–4
426 x 732 cm
Courtesy Maureen Paley, London

pages 68–9
John O'Connell
Landscaping
Super 8 mm film stills
2005

pages 70–1
Cornelia Parker
Explosion Drawing
Charcoal, sulphur and saltpetre
2001
61 x 61 cm
Courtesy the artist and Frith Street Gallery, London
Photograph by Stephen White

page 72
Cornelia Parker
Pornographic Drawing

Ink made from dissolving video tape (confiscated by
 HM Customs & Excise) in solvent
2005
61 x 61 cm
Courtesy the artist and Frith Street Gallery, London
Photograph Stephen White

Cornelia Parker
Subconscious of a Monument
Soil excavated from beneath the Leaning Tower of
 Pisa, wire
2002
Dimensions variable
Installation view, RIBA London, 2005
Courtesy the artist and Frith Street Gallery, London
Photograph Stephen White

page 73
Charles Poulsen
27th January 2006, Two
Wax stick and black gouache on Fabriano
2006
94 x 94 cm

page 74
Matthew Ritchie
*Installation View of the Elector Series at Portikus,
 Frankfurt-am-Main, Germany*
Mixed media
2005
© Matthew Ritchie
Courtesy Andrea Rosen Gallery, New York

page 75
Matthew Ritchie
Elector Anne IX
Ink on Denril
2005
30.48 x 22.86 cm
© Matthew Ritchie
Courtesy Andrea Rosen Gallery, New York

pages 76–7
Annette Robinson
'Kinder' Drawing series
Tracing paper, drafting film, gel pen, pen and ink
2005
21.8 x 29.7 cm

page 78
Ugo Rondinone
FUENFZEHNTERJUNIZWEITAUSENDUNDDREI
Ink on paper, wooden frame
2003

200 x 300 x 3 cm
Private collection, Belgium
Courtesy Galerie Eva Presenhuber, Zürich

page 79
Ugo Rondinone
*NEUNUNDZWANZIGSTERJULIZWEITAUSENDUNDZ-
 WEI*
Ink on paper, wooden frame
2002
200 x 300 cm
Collection Milgrom, Melbourne
Courtesy Galerie Eva Presenhuber, Zürich
Sadie Coles HQ, London

pages 80–3
Anne-Marie Schneider
Vertige d'Amour
Graphite on paper
2005
11 ⅞ x 8 ½ inches
All images are courtesy of the artist and Tracy Wil-
 liams, Ltd, New York

page 84
David Shrigley
Untitled
Ink on paper
2005
25.4 x 30.47 cm

David Shrigley
Untitled
Ink on paper
2005
25.4 x 30.49 cm

David Shrigley
Untitled
Ink on paper
2005
25.4 x 30.44 cm

page 85
David Shrigley
Untitled
Ink on paper
2005
25.4 x 22.83 cm

David Shrigley
Untitled
Ink on paper

2005
25.4 x 30.52 cm

David Shrigley
Untitled
Ink on paper
2005
25.4 x 31.32 cm

page 86
David Shrigley
Untitled
Ink on paper
2005
25.4 x 31.32 cm

David Shrigley
Untitled
Ink on paper
2005
25.4 x 22.83 cm

page 87
Barthélémy Toguo
The Lovers Bed II
Watercolour on paper
2004
112 x 110 cm

page 88
Stephen Walter
The Suburban Isles (Similands)
Pencil on paper collage
2004–5
75 x 99 cm

page 89
Stephen Walter
Detail 2 Throw Away After Use, A London Town
Pencil on paper
2002–4
101 x 153 cm

page 90
Stephen Walter
*Detail 3 Once Upon a Time – There was a Land Covered
 in Forest, Then There was a City, Then a Suburbanite
 Thinking About Trees*
Pencil on paper
2002–4
100 x 75 cm

page 91
Monika Weiss

artwork details

*Lethe Room: View of the Installation at the Lehman
 College Art Gallery*
Plaster, metal, wood, motor, crayons, pigment, paper,
 the artist
2004
92 x 125 x 60 inches

page 92
Sarah Woodfine
The Garden
Pencil on paper in perspex box

2005
17 x 85 x 16 cm
Courtesy Danielle Arnaud contemporary art

page 93
Sarah Woodfine
Untitled (Castle)
Pencil on paper in snow dome
2005
38 x 38 cm
Courtesy Danielle Arnaud contemporary art

page 94
Edwin Wurm
Spanish/American Table of Conspiracy
Pen and paper
2003
29.7 x 21 cm

page 95
Edwin Wurm
The Idiot
Pencil and paper
2003
29.7 x 23 cm